BOSTON

BOSTON

Distinguished Buildings & Sites
Within the City and its Orbit
as Engraved on Wood by
RUDOLPH RUZICKA
With a Commentary by
WALTER MUIR WHITEHILL

DAVID R. GODINE · PUBLISHER
Boston

David R. Godine, Publisher
Boston, Massachusetts
Printed in the United States of America
Text copyright © 1975 by Walter Muir Whitehill
Illustrations copyright © 1975 by Rudolph Ruzicka
LCC 74-30913 ISBN 0-87923-124-6

CONTENTS

Preface

In a discussion of the relative importance of environment and heredity, something might be gained from considering the twenty-nine wood engravings reproduced in this book. Although they represent to most Bostonians the 'authorized version' of their city, their engraver was born in Bohemia in 1883, grew up in Chicago, and lived in the vicinity of New York City while he was doing them, while the printer who commissioned them was a native of Rhode Island, whose high Anglican proclivities had little relation to the Puritan-Unitarian views of his Boston neighbors. Rudolph Ruzicka, who now lives and works in Norwich, Vermont, was the subject of chapter xv of my *Analecta Biographica, A Handful of New England Portraits* (1969); the life of Daniel Berkeley Updike (1860–1941) I summarized for the *Dictionary of American Biography, Supplement Three* (1973). But the character of the men and the nature of their collaboration will best be indicated by quoting a few paragraphs from the chapter 'Fragments of Memory' that Mr. Ruzicka contributed to *Recollections of Daniel Berkeley Updike*, published in 1943 by the Club of Odd Volumes:

> Among the many illuminating quotations in Updike's conversation and writing, Sir Walter Raleigh's 'Write, and . . . you write yourself down whether you will or no' is at this moment uppermost in my mind. The following

paragraphs about one who wrote and printed himself down so effectively have become, I find, unconsciously autobiographical. They were prompted by memories of continuous friendship of long standing and they are personal; however much he stressed tradition and forms, Updike sought and valued above all things the basic realities of human relationship, sincerity, truth, and affection.

Our first meeting took place at the Hotel Lafayette in New York in 1907. I was recommended to Updike by Lewis Hatch for the engraving of a title page decoration intended for a volume of *The Humanist's Library*. I liked the 'manuscript' of the design which proved later to be by Dwiggins and undertook the reproduction, carefully instructed by Updike as to the character of the line and feeling that were to be preserved. Though not much feeling remained when I finished the work, the engraving was finally accepted and used. But my first meeting with Updike ended in a spirited disagreement; the argument, I believe, concerned a question of contemporary art. Updike was then in his Renaissance mood and I thought him arrogantly opinionated.

Two or three years later I made my first visit to Boston in company with a friend. Our main purpose was to see Dwiggins, whom we found working in his studio on the concave side of Cornhill. I had brought with me a portfolio of a dozen of my engravings; wood-engraving was little practiced at that time—it was certainly unsung. These 'original' engravings then I took to show Updike at The Merrymount Press in Summer Street (having advised with Dwiggins as to the wisdom of doing so) and to

my surprise, at this second meeting, I found quite a different man, simple, appreciative, pertinently critical; flattering in that he showed me his own work.

Thus began a friendship with a man almost twice my age, and, as he then seemed to me, ten times more experienced and clever than I. What made our relations easy was the fact, I suppose, that I was not 'on the make' and was not 'a brilliant bore', to use his favorite phrases. My admiration for his work and a desire to understand it helped as did perhaps the divergent character of our backgrounds.

At that time Updike strongly emphasized the genealogical and the social; to many he must have seemed a kind of walking Debrett and Social Register combined. Early in our acquaintance I remember listening patiently, in my workroom in Lexington Avenue, to a detailed account of a fashionable person of his social world. In a fit of youthful sincerity I said something to the effect that he was too accomplished a man to make so much fuss about what did not appear to me important; he did not bite my head off as I half expected but apologized disarmingly, saying: 'That is the way I was brought up.' Later when I was privileged to meet some of those friends they turned out to be real and wholly delightful people. Yet another remark of mine, provoked in argument and made in a state of premature 'modernism', that he abandon the use of borrowed historical ornament, was ignored in charitable silence. Such friendly impertinences and misunderstandings were not too many and in the end helped clear the air for us both. Foundations of a friendship and later foundations of another kind were laid. He sent me at intervals of time a pound of Ceylon tea, a box of Castile soap and a copy of the Book of Common Prayer. With the last came a note: 'Having

sent you Tea, Soap and the Prayer Book, you are now provided with the Foundations of Anglo-Saxon Culture.'

ANNUAL KEEPSAKES

The series of my engravings of New Years cards begun in 1911 and sent to the Friends of The Merrymount Press were originally proposed by John Bianchi. The subject was often suggested by Updike himself, and sometimes he would come with me while I made the sketch—pouring out his intimate and highly entertaining knowledge of places and people. Thus I came to know the furnishings and inmates of a kitchen in a house on Beacon Hill, and the history of, and an anecdote about, the weathervane on the top of Faneuil Hall. My chief concern however was with the designs and their execution and of this I could never convince a distinguished lady who more than once reproached me for engraving 'too many red brick churches.'

The Latin inscriptions, almost always apt (I could never agree, however, that *Arabia Deserta* was applicable to Worcester Square), often pointed, sometimes humorously puzzling, were Updike's special care. Here again my interest was largely formal and technical. Lettering is harder to engrave than portraits; everyone knows the physiognomy of letters and is a critical relative, most of all of course the great historian of type faces for whom the engravings were made.

Mr. Updike's death in 1941 brought the series to an end. Some friends at least received the final engraving on the sombre day in late December 1941 when they had attended his funeral at the Church of the Advent in Boston. Waves breaking against Minot's Light seemed a singularly appropriate subject for a moment of personal loss in a season

X

of national gloom and uncertainty. There were altogether twenty-nine views in The Merrymount Press series; sixteen were of scenes within the city limits of Boston, while the remainder were of subjects in the vicinity. As they were sent out to convey New Year's Greetings, Mr. Ruzicka's work was always done in the year preceding the dates in the titles. The keepsake for 1919 was a symbolic commemoration of Armistice Day; that for 1925 reproduced a decorative design by Jean Pillement, for Mr. Ruzicka was travelling in Europe at the time.

Complete sets of the keepsakes have long been a rarity. Not too many friends were on the mailing list during the entire thirty-one years. Some recipients who were obtuse enough to confuse them with the general mid-winter flood of 'greetings' doubtless threw theirs away. I first encountered them as a Harvard freshman in 1922, through the fortunate accident of coming to know George Parker Winship, Librarian of the Harry Elkins Widener Collection in the Harvard College Library, who had a contagious enthusiasm for fine printing, ancient and modern. Through him I first saw some of the handsomer products of The Merrymount Press; under his auspices I met Daniel Berkeley Updike, and by the mid-twenties happily found myself on the distribution list of the keepsakes. But it took me a good many years of searching to fill out the earlier engravings in the series. It gave me particular delight when Augustus Peabody Loring, Jr., in 1951 gave the Boston Athenaeum a set of Mr. Ruzicka's proofs of the entire series in memory of his wife, Rosamond Bowditch Loring, who had died the previous year. Although The Merrymount Press printed the blocks with great care, the artist's proofs are even subtler in their coloring.

Mr. Ruzicka began to engrave views of cities almost seventy years ago; I have had the honor of his friendship

for half that time. He had been brought from his native Bohemia to Chicago by his parents in the early 1890's. In a letter of 1919 to a teacher of art in Toledo, Ohio, he thus described the road that led him to the graphic arts:

The thing that most stands out in my mind, when I think of my first years in this country, is my struggle with the English language and the resulting sense of loneliness. But I got on famously in the Public Schools after the rather humiliating experience of having to start in the first grade, at 11 years of age. I went to school just three years, passing through seven grades; rapidity of progress I ascribe to my ability to draw. I decorated the blackboards of nearly all the school rooms and I gained thereby much favor with the teachers. Saturday afternoons I attended drawing classes at the Hull House.

Then at 14 years I had to seek a job and found one, after much hunting, at commerical wood-engraving, in an engraving house. I took my work extremely seriously and remember that when the firm that employed me was denounced for employing a minor, (I was found doing a journeyman's job) I argued very heatedly in Court, claiming that I was not doing factory work, but Art Work! much to the astonishment of every one in the court room. This happened after about six months in this shop—all that time I received no salary; then they 'raised' me $1.00 a week. Soon after that I secured another position where I received $8.00 a week. In another six months I gave up engraving and took up designing. In the meantime I attended night classes at the Art Institute.

Early in 1948, when I was preparing an essay for the catalogue of a Grolier Club event, *The Engraved and Typographic Work of Rudolph Ruzicka, An Exhibition* (subse-

quently reprinted in *Analecta Biographica*), I was in frequent communication with him. In a letter of 10 February 1948 he remarked:

I have a kind of horror of the self-made man, because of course everyone is that in so far as he did anything at all. I say this apropos of the copy of my letter to the school teacher which I sent you and which is the only autobiographical and didactic thing I ever wrote.

Nevertheless it is to me a vignette of American life three-quarters of a century ago that merits perpetuation.

In 1903, at the age of twenty, Mr. Ruzicka moved to New York, and worked for a time in an advertising agency, while continuing his studies. In 'A Note on the Exhibits' in the Grolier Club catalogue, he wrote:

It was around 1906, at a time when the white line reproductive wood engraving virtually ceased to be practised, that I quite suddenly returned to the trade in which eight years before I had a year's apprenticeship. Inspired by Lepère's romantically topographic engravings and other contemporary work exemplifying a new approach to the medium, I spent many late hours in my New York bedroom over engravings of my own design.

In less than a year enough was accomplished to make me dissatisfied with the hand-rubbed proofs and I therefore turned to a professional woodcut printer then still surviving in Fulton Street, with results that sometimes proved uncomfortably revealing. Soon, in Goudy's shop in the Parker Building, I was permitted to use his hand press and finally, in the back parlor of a 'brownstone' near Sutton Place and the East River, I had my own press, put up with Goudy's assistance.

The traffic on the East River, the coal pockets along the

shore, and the Queensboro Bridge provided subjects for the earliest engravings which were shown to Mr. Updike on Mr. Ruzicka's first visit to The Merrymount Press in Boston. Of these early views of New York, Mr. Updike wrote in the September 1917 issue of *The Printing Art*:

One of the qualities in Ruzicka's work is its actuality. He seizes the picturesque side of a 'Gospel tent' at night, with its violent contrast of light and shade, or a gasometer, or a Ferris wheel, as some others have done; but actuality is not all, for he makes them pictorially his own, presents them always *more suo*. To be able to see picturesque qualities where other people see nothing is the power of the seer; to convey them to others is the power of the interpreter.

Yet he could also produce such an unsurpassed rendering of a formal architectural subject as the 1911 engraving of St. John's Chapel in Varick Street. An impression of this largest of his black and white blocks (6¾″ x 10¾″) has hung in my front hall for many years, holding its own admirably in the company of several of Piranesi's works on copper.

Mr. Updike was not alone in appreciating the quality of these prints. In 1912 Auguste Lepère, whose work had led Mr. Ruzicka to return to the medium, invited him to send samples of his wood engravings to Paris for the first exhibition of the Société de la Gravure sur Bois Originale, held at the Pavillon de Marsan in the Louvre. The following year the Grolier Club commissioned him to begin work upon *New York, A Series of Wood Engravings in Colour*, for which Walter Prichard Eaton wrote prose impressions of the city. There were ten full-page engravings, each 4½″ x 6⅞″, which he had intended to print himself. As he set out for Rome in November 1913 to undertake illustrations

for Mrs. Charles MacVeagh's *Fountains of Papal Rome*, he left the New York blocks in Paris with Emile Fequet—Lepère's own printer—who printed them admirably. The twenty smaller head and tail pieces and the text were printed for the club by the De Vinne Press in an edition of 253 copies. The brilliance of this work inspired the Carteret Book Club of Newark to seek a similar presentment of their city in line, color, and prose. For *Newark, A Series of Engravings on Wood* Rudolph Ruzicka himself printed five full-page engravings in color, somewhat larger than the New York ones, while the text and eleven smaller black and white blocks were printed at The Merrymount Press in an edition of 200 copies, completed in November 1917.

Alas, the views of Roman fountains were less fortunate in their printers. For Mrs. MacVeagh's book, Mr. Ruzicka achieved a series of fourteen full-page and twenty-nine smaller illustrations that, without the aid of color, captured the sparkling exuberance of the Eternal City. Although The Merrymount Press had made preliminary typographical designs for the book, it was, when published in 1915 by Charles Scribner's Sons, printed elsewhere. In published form one sees the engravings 'through a glass darkly' for indifferent presswork marred their brilliancy. In the Grolier Club exhibition of 1948, I noted that

> One sees the artist's own proofs and can appreciate the magnificence—and almost feel the cold water—of the Tartarughe, the Tritone and the other fountains of the Eternal City. One cannot help feeling that Bernini would have rejoiced to see his work so subtly though so simply engraved.

It is to be regretted also that a book on Czechoslovakia, projected by Chatto and Windus in the early 1920's, was never published, for Mr. Ruzicka made numerous sketches

and water colors of his native country for this volume. A wood engraving in five colors of the Charles Bridge at Prague, which was to have been the frontispiece, and some other blocks, were prepared. After the book was abandoned, a few of the subjects were separately engraved in a larger size.

In 1917 William M. Ivins, Jr., Curator of Prints at the Metropolitan Museum, in his essay, *The Wood Engravings of Rudolph Ruzicka*, remarked of the Boston series that

> such woodcuts as the Louisburg Square, Faneuil Hall, and the Old State House are correct in every Bostonian sense of the word, a little dry, a little precise, quite restrained, and just a little backward looking to the older times of the shallow, straight-backed chair which forbade lounging, in a word, charming records of a prime provincial elegance that seemed about to depart.

Oddly enough, it did not depart. The New York and Newark engravings suggest a lost world. The Boston buildings, like our flag, are still there. An occasional horse, fishing boat, or detail of costume will remind the viewer that the most recent of the Boston series was engraved more than a third of a century ago. As a whole, however, the subjects are still recognizable.

It is unfortunate that few people have the opportunity to enjoy Rudolph Ruzicka's perceptive views of cities. The New York and Newark volumes, having been produced in small editions, have long been rare books. His engravings of Rome and Prague can only be seen in a few institutions, or at one of the recurring exhibitions of his work. The Boston series, which has long been hard to come by, now becomes available in reproduction in this volume, through the skill of The Meriden Gravure Company and the imagi-

nation of David R. Godine, who wished to place these

views of Boston within reach of residents in and visitors to the city. In making the color separations for the reproductions, various of the original blocks, now in the Boston Athenaeum, have been helpful.

It is unnecessary to comment upon the engravings. They speak for themselves. Consequently in the pages that follow my text is chiefly concerned with the views that they depict. Nor do limits of space permit me to speak of phases of Mr. Ruzicka's work other than his views of cities, save to point out that the Boston series here reproduced was his last major work of wood engraving in several colors. In the past third of a century he has turned his attention to type design, to calligraphy, and to various kinds of drawing. Type faces, book designs, alphabets, institutional seals, diplomas, bookplates, and decorative designs of many kinds constantly come from his drawing board to delight his friends and admirers. I hope some day there will be a detailed catalogue of all his varied contributions to the graphic arts. Against the day when that is prepared, I wish to record here some of the views of Boston that he has drawn beyond The Merrymount Press keepsake series.

On larger blocks (5″ x 7⅜″) than were used for the keepsake series, Mr. Ruzicka in 1916 engraved in black and four colors a view of Cornhill, the curving street that was then a favorite location for booksellers and graphic artists. This was not a commission, but a print undertaken for his own pleasure, doubtless because of pleasant recollections of the street when he went to the studio of William A. Dwiggins during his first visit to Boston. This is the only one of his Boston subjects that has not survived, for the side of Cornhill that he drew was demolished in creating the site for the present City Hall.

The Iconographic Society, founded in 1898 by ten members of the Club of Odd Volumes to publish prints of old

Boston buildings and landmarks, appeared initially an elegantly concealed excuse to provide commissions for Sidney L. Smith, for all six prints of Series I (1898–1904) are his work. For Series II (1911–1917) several eminent printmakers, including D. Y. Cameron, Axel H. Haig, and D. Shaw MacLaughlan, were commissioned to do etchings; as these prints were done from photographs, rather than on the spot, they were not especially distinguished. After a lapse of ten years, a third series, devoted to the architecture of Charles Bulfinch, was inaugurated in 1927 by Rudolph Ruzicka's large engraving (4½″ x 6‍¾₆″) of the third Harrison Gray Otis House at 45 Beacon Street. One hundred impressions of this print, which was unquestionably the handsomest publication of the Iconographic Society, were issued in a folder with illustrative notes by Samuel Eliot Morison, splendidly printed by The Merrymount Press.

The First Church of Christ, Scientist, in Boston was not a subject that appealed to Mr. Updike either theologically or architecturally. Nevertheless Mr. Ruzicka was commissioned by the Christian Science Publishing Society to do a color engraving of it that was used in 1939 as a frontispiece for Margaret Williamson's *The Mother Church Extension*. In size and manner it is similar to the Merrymount series, save for the absence of a Latin text.

Among Rudolph Ruzicka's commissions for the Department of Printing and Graphic Arts, established in the Houghton Library by Philip Hofer, were an aquatint of the Houghton Library, Harvard University, colored by hand (1941), and a water color of the Harvard Houses seen from the Western Avenue Bridge.

For the title page of the 1942 Year Book of the Club of Odd Volumes, of which he has long been an honorary member, Mr. Ruzicka did a pen-and-ink drawing of the façade of the club house at 77 Mount Vernon Street. This has

frequently been used by the club in later publications. At this point I begin to prove the truth of Sir Walter Raleigh's earlier-quoted observation, for this was one of the last club publications that I, as Clerk, saw through the press before leaving for four years active duty in the Naval Reserve.

When in 1946, while still on duty at the Navy Department, I accepted the direction of the Boston Athenaeum, I thought at once of the delightful prospect of inducing Mr. Ruzicka to do a series of views of that library. An album of six views, showing the façade and each one of the superimposed reading rooms, was published by the library in 1952. These were pen-and-ink drawings, reproduced by the Anthoensen Press, with one color added. Unlike nearly all of Mr. Ruzicka's works, these drawings are still available at the Athenaeum. During my twenty-six years there, I embraced every opportunity to have Mr. Ruzicka improve the quality of the library's bookplates. Although all of these furnish delightful examples of his calligraphy and decorations, only one shows a view of Boston. When Howard W. Lang, who had long lived at 49 Mount Vernon Street, removed to Florida, he gave the Athenaeum a fund for the purchase of books. In a Ruzicka drawing the likeness of Mr. Lang's house appears on the plates of books bought through his thoughtfulness, as a pleasant reminder of an old friend who was almost daily in the library.

In writing my *Boston Public Library, A Centennial History*, I was anxious to avoid reproducing endless likenesses of worthies and benefactors. I therefore proposed that the book be illustrated only by Ruzicka drawings. The book, published by the Harvard University Press in 1956, was designed by Mr. Ruzicka in his Fairfield Medium type and adorned by fourteen of his pen-and-ink drawings. Six of these were impressions of the main library in Copley Square. The frontispiece showed it across the square as

seen from Trinity Church, while a detail of the main entrance decorated the dust jacket. There were views of Bates Hall, the main staircase, and the courtyard, as well as the Bacchante that briefly enlivened the court fountain in 1896. The latter drawing was earlier used on the notice of the 19 May 1954 meeting of the Club of Odd Volumes, at which I recounted 'The Vicissitudes of Bacchante in Boston.' To recall earlier homes of the library, there was a drawing of the Mason Street schoolhouse, where it opened in 1854, and the exterior and upper hall of the Boylston Street building, occupied from 1858 to 1895. The West Church, which was the subject of one of the Merrymount Press keepsakes, was illustrated here as the oldest of the branch libraries, while two views of the recent Adams Street Branch and a Bookmobile brought the story down to date.

When L. H. Butterfield was preparing *Walter Muir Whitehill A Record Compiled by His Friends* for presentation at a surprise party at The Glades, Minot, Massachusetts, on 13 September 1958, Rudolph Ruzicka was one of the benevolent conspirators. Spirited to 44 Andover Street, North Andover, by my daughters during my absence, he did five drawings of my house and barn, study and garden, in the manner of the Boston Public Library views. His drawings of the exterior of the house we have used on letter paper ever since.

In designing *The Library at the Heart of the Harvard Medical Center*, a fund-raising pamphlet for Harvard University in 1957, Mr. Ruzicka drew a page of schematic views of the Massachusetts General & McLean Hospitals, the Boston Lying-in, the Children's, the Beth Israel, the Peter Bent Brigham, the Free Hospital for Women, and the Massachusetts Eye & Ear Infirmary in their relation to the Harvard Medical School. The pamphlet obviously served its purpose, for the Countway Library of Medicine,

dedicated in 1965, was the result. Another sketch of one of these institutions appeared in 1963 in David McCord's *The Fabrick of Man, Fifty Years of the Peter Bent Brigham.*

On my retirement from the Boston Athenaeum in 1973, Mr. Ruzicka drew for Andrew Oliver, one of the trustees, a sketch for a medal with my portrait in profile on the obverse. On the reverse was the entrance to the library, and the text: DIRECTOR AND LIBRARIAN BOSTON ATHENAEUM 1946–1973. HE PUT PEN TO PAPER & PRESERVED A CITY. Andrew Oliver had proposed a Latin inscription. Rudolph Ruzicka supplied the wording of an English alternative that greatly touched me. How well one might say of him: HE PUT BURIN TO BOXWOOD & PRESERVED CITIES.

A few weeks later a group of members of the Club of Odd Volumes gathered in Hanover, New Hampshire, to celebrate Mr. Ruzicka's ninetieth birthday, 29 June 1973. For this occasion David McCord wrote:

R R
LINES, SHARP AS SERIFS,
ON BYPASSING HIS NINETIETH BIRTHDAY

Rudolph, in searching as I would
for some good symbol of this day,
aware of how with Time you've stood,
knowing your no-attention way

with milestones, even with a choice
four-score-and-ten at your disposal,
I wished no *long propos* to voice:
just one brief *apropos* proposal.

Figure, then, to yourself the year
when I was not much more than nine,
living in Princeton, rather near
to Princeton Junction on the line—

the main line: Philadelphia from
New York and vice versa, when
the age of steam had not yet come
a cropper. What did I do then?

I'd ride my bicycle to wait
Promethean engines (four-six-two's,
they were, in railroad language) great
beyond the power of the Muse.

Like flowers bursting into bloom,
when botany goes on the screen,
the headlong wild express would loom
(Oh, marvel some have never seen!)

in manned momentum hurtling down
the stretch where ballast held the four
tracks tighter than the strings that crown
the violin. All this no more;

but, Rudolph, that was how it went
at Princeton Junction. One would cower
to see what grace perfection lent
to clocking ninety miles an hour.

How could I realize that here,
where crossings used the double R
in caps, those letters would appear
to testify the avatar

of graphic arts, exquisite taste
in books and learning; infinite friend
of us so many so far outpaced!
Indeed, indeed, just two R's penned,

italicized in every eye,
are all we need to tell us that
perfection is to simplify
at ninety, running on the flat.

Ninety copies of this poem were printed by The Stinehour
Press, as a collective gift to Mr. Ruzicka from his fellow
members of the club. As it has not otherwise been pub-
lished, I am glad that Mr. McCord gave permission for
me to reprint it in this book.

My granddaughter, Diana Randolph Laing, came from
London for a visit in July, while I was writing the text that
accompanies the engravings. As these views of her native
Boston, which she has seldom seen in recent years, gave
her pleasure, I dedicate my share in this book to her, and
subscribe it on her seventeenth birthday.

WALTER MUIR WHITEHILL

North Andover, Massachusetts
3 August 1974

BOSTON

I

A View of the Old State House,

Boston, 1912

For the thirty years following 1912, engravings by Ru-
dolph Ruzicka brought Mr. Updike's New Year's Greet-
ings to the friends of The Merrymount Press. A short,
pithy Latin inscription detained the attention and encour-
aged a second look at each view. As the text chosen for the
first of the series (Luke 5:39, presenting Jesus Christ's
judgment of wine) suggested that the old is better, it was
appropriate that the subject chosen for illustration should
be the oldest surviving public building in Boston. More-
over, this building stands on a site that was at the very
heart of colonial Boston: the ancient market place at the
junction of State (formerly King) Street, which led into
town from the harbor, and today's Washington Street
which, before the days of bridges, was the only road lead-
ing to the Roxbury mainland from the water-ringed penin-
sula on which Boston sat. On this site was built in 1657 a
wooden Town House with funds bequeathed the previous
year by Robert Keayne, a transplanted London merchant
tailor who had prospered in New England. His will envis-
aged a many-purpose building, 'useful to the country peo-
ple that come with their provisions for the supply of the
town, that they may have a place to sit dry and warm both
in cold, rain, and dirty weather,' that would provide 'some
convenient room or two for the courts to meet in . . . and
2 also for the townsmen and commissioners of the town,' a

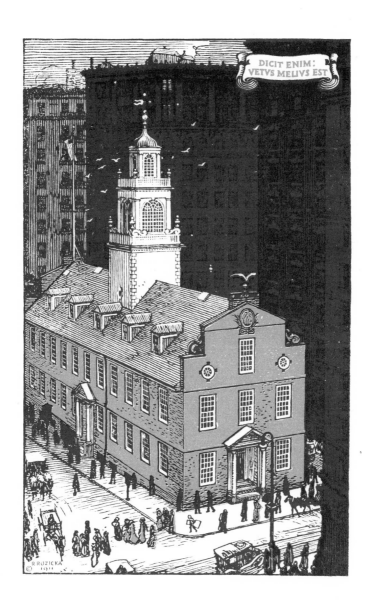

library, and an armory for the Artillery Company. After 1686 the first Town House also provided an improvised rustic seat for the royal government of the province of the Massachusetts Bay.

After in the evening of 2 October 1711 it had been destroyed in a disastrous fire that devastated the center of Boston, the Town House was rebuilt in brick in much the form shown in this engraving. Although the interior of the new building was gutted by fire in 1747, the exterior still preserves much the appearance of the structure built after the fire of 1711. Within its walls James Otis in 1761 delivered his impassioned plea against the Writs of Assistance. There on 29 October 1765 Samuel Adams presented his resolution 'that all acts made by any power whatever, other than the General Assembly of this province, imposing taxes on the inhabitants, are infringements of our inherent and inalienable rights as men and British subjects.' Below the windows of this building on 5 March 1770 the Boston Massacre took place. The Declaration of Independence was read from its balcony on 18 July 1776.

The second Boston Town House served as the seat of the Massachusetts government from independence until 1798, when the present Bulfinch State House on Beacon Hill was ready for occupancy. At this point the 1711 building acquired the current name of the Old State House. For the next three decades it was rented out for stores and offices. It came within an ace of demolition in 1826 when a group of Bostonians who had commissioned Sir Francis Chantrey to carve a marble statue of George Washington wished to place this monument in a new building on the site. This proposal caused such public complaint that in 1830 the Old State House was refitted as a City Hall and Chantrey's Washington found a less pretentious setting in Doric Hall in the present State House.

4

When the city government moved in 1841 to a larger building in School Street, the Old State House again reverted to undignified uses. Plastered over with signs, and disfigured by a mansard roof that was supposed to make it seem attractively 'modern' to a job-lot of miscellaneous tenants, it became an eyesore. 'So completely were the memories of the site forgotten, and so arrogant were the fancied demands of commerce,' William H. Whitmore wrote, 'that in 1875, it was almost decided to pull down the building.' But in 1876 a popular clamor had saved the nearby Old South Meeting House from destruction. The historical associations of the Old State House were strikingly similar to those that had saved the meeting house, especially in the year of the Centennial. So in 1881 the Boston City Council authorized a thorough restoration, which was completed at public expense the following year at a cost to the taxpayers of $35,000. While the restoration hardly returned the interior to its eighteenth-century disposition, it represented a commitment by the city government to the cause of historic preservation. The Bostonian Society, a new organization dedicated to the history of the city, was installed in the Old State House to maintain a museum of local history, which it has done, within rigorous limitations of space, for nearly a century.

A View of Faneuil Hall,
Boston, 1913

Although Robert Keayne's proposal for the first Town House of 1657 had included shelter against 'dirty weather' for 'the country people that come with their provisions for the supply of the town,' Boston did not have a proper market house until the second third of the eighteenth century. Captain Nathaniel Uring, an English visitor to Boston in 1709, observed: 'Though the town is large and prosperous, they could never be brought to establish a market in it, notwithstanding several of their governors have taken great pains to convince the inhabitants how useful and beneficial it would be to 'em, but the country people always oppose it. Their reason is, if market days were appointed all the country people coming in at the same time would glut it, and the townspeople would buy their provisions for what they pleased. So they rather choose to send them as they think fit, and sometimes a tall fellow brings a turkey or goose to sell, and will travel through the whole town to see who will give the most for it, and it is at last sold for 3s. 6d. or 4s., and if he had stayed at home he could have earned a crown by his labor.' As complaints against such hucksterism multiplied, the town in 1734 established three market places, one in the North End, another in the South End, and the third near the Town Dock, where Faneuil Hall now stands. After 6 less than four years of trial, the plan was abandoned.

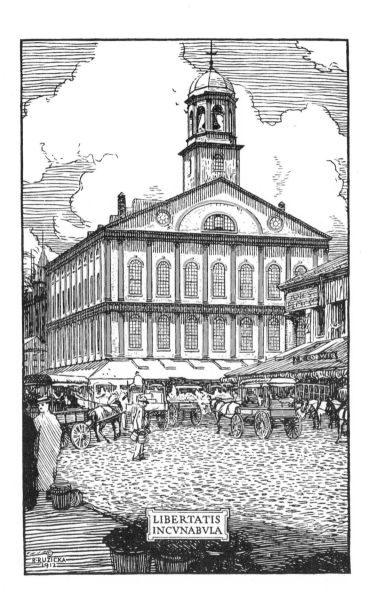

LIBERTATIS
INCVNABVLA

The matter came up again in 1742 when Peter Faneuil (properly pronounced Funnel), son of a Huguenot merchant from La Rochelle who had settled in Boston in 1691, offered to build at his own expense 'a noble and compleat Structure or Edifice to be Improved for a Market, for the sole Use and Benefit and advantage of the Town, Provided that the Town of Boston would pass a Vote for that purpose.' A petition supporting the offer, signed by 340 citizens, was considered at a town meeting on 14 July 1740. After a deal of ungrateful debate, Faneuil's offer was accepted by a vote of 367 to 360! In consequence Peter Faneuil built a two-story brick structure, one hundred feet long and forty feet wide, designed by the painter John Smibert. As in many English buildings, above the ground-floor market there were rooms for town offices and a sizable hall, to which the town meeting of 13 September 1742 unanimously gave the name of the donor. Faneuil Hall became the scene of town meetings and other gatherings so significant in the events leading to the American Revolution that it came to be called the Cradle of Liberty, a phrase Latinized in this engraving as LIBERTATIS IN-CUNABULA. Such metaphorical phrases in any language lead to confusion. A few years ago the promotional literature of a Boston tourist trap, now mercifully vanished, suggested that, through its dioramas, one could look inside the cradle and see Liberty being born!

A fire on 13 January 1761 consumed all but the brick exterior walls of Faneuil Hall, including a portrait of George II that Governor William Shirley had given in 1742. Peter Faneuil had died on 3 March 1743, but with funds raised by a municipal lottery his benefaction was promptly rebuilt in the manner originally designed by John Smibert. When the growth of the town required greatly increased space for both victuals and town meet-

ings, Faneuil Hall was enlarged to its present dimensions in 1805 by Charles Bulfinch, who doubled the width of the building and added a third story. He retained Smibert's south and east walls; the Tuscan and Doric pilasters of the first and second stories were copied in the new work, and an Ionic order provided for the third story. The octagonal cupola, originally rising from the center of the roof, was, however, shifted to the east façade, where it was still surmounted by Shem Drowne's weathervane in the likeness of a grasshopper. This weathervane was often used by United States consuls in distant ports in testing the veracity of distressed seamen seeking repatriation to Boston. Only those who correctly identified the grasshopper got their passage paid. Thus in 1805 a two-story building, nine bays long and three wide, was enlarged to the height of three stories and width of seven bays without change in length. Bulfinch's very much larger galleried hall was lighted from second- and third-story windows, while a commodious armory for the Ancient and Honorable Artillery Company was provided in the attic. In 1898–1899 Faneuil Hall was reconstructed by the City in an effort to increase its safety from fire while respecting Bulfinch's plans.

Since Rudolph Ruzicka engraved this view in 1912, both horses and the wholesale markets have left the scene, but the completion of the new City Hall nearby in 1967 means that Faneuil Hall is as much at the center of things in the twentieth-century city as it was in the eighteenth-century town to which Peter Faneuil gave it.

A View of the Old West Church,

Boston, 1914

In his choice of a subject for the third of the series, Rudolph Ruzicka moved from the ancient center of Boston to the West End, then a crowded slum. As I have explained in my *Boston, A Topographical History,* the English Puritans of the Massachusetts Bay Company who arrived in New England in 1630 established their settlement on a hilly peninsula, completely ringed around by water save for a narrow neck that led to the Roxbury mainland. The town was, in popular parlance, divided into 'Ends.' The North End, just across Mill Creek from the center, where the Old State House and Faneuil Hall still stand, was the most densely settled area in the colonial period. The original South End, which was more open, consisted of the region between to-day's Milk, Washington, and Essex Streets and the harbor. Behind the once three-peaked Trimountain, of which Beacon Hill is the only survivor, and extending down to the tidal shore of the Charles River, was the West End. Until the second third of the eighteenth century this was an inaccessible, countrified, sparsely settled quarter. As new streets were laid out through its pastures, the Lynde Street Meeting House was built in 1737 for an inducement to the development of the West End as a new residential area. The opening in 1793 of the West Boston Bridge—the second to link the peninsula to the Cambridge shore—greatly accelerated the process, for it made Bowdoin Square and

10

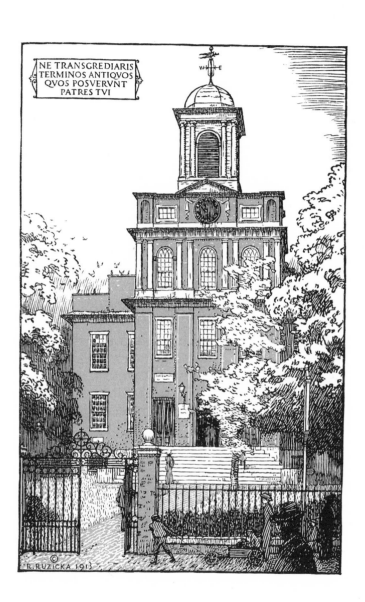

NE TRANSGREDIARIS
TERMINOS ANTIQVOS
QVOS POSVERVNT
PATRES TVI

R. RUZICKA 1913

Cambridge Street part of the most direct road from Boston to Cambridge and Harvard College.

From this moment the West End became a fashionable residential district that eclipsed the more crowded colonial North End. Boston's greatest architect, Charles Bulfinch, soon built in the vicinity of Bowdoin Square a number of his finest mansions for Federalist merchants who were prospering from the newly extended routes of overseas trade. By 1806 the simple meeting house of 1737 at the corner of Lynde and Cambridge Streets was replaced by the handsome brick one depicted in this engraving. The new church was the work of Asher Benjamin, an architect and housewright who between 1797 and 1830 published four books of designs for houses and churches that were widely copied throughout New England by less imaginative builders. The Reverend Charles Lowell, father of the poet James Russell Lowell, was ordained as minister of the new church.

Until the end of the Civil War, the West End continued to be a handsome residential district. As late as 1860, when the future Edward VII was, as Prince of Wales, touring the United States, the Revere House in Bowdoin Square enjoyed sufficient reputation as a hotel to be chosen for his accommodation. The last third of the nineteenth century saw a gradual decline in the neighborhood. Slowly but inexorably, families deserted the West End for the new Back Bay. One by one the Federalist mansions designed by Charles Bulfinch were demolished or altered for ignoble uses. Before the century was over, the region was a polyglot slum. By 1892 the West Church had closed its doors for want of a congregation in the neighborhood.

At this critical point, Andrew C. Wheelwright, a lawyer living in Mount Vernon Street on Beacon Hill, heeded the admonition of Proverbs 22:28 and bought the church. With outstanding public spirit and concern for architectural qual-

ity, he held it until the Boston Public Library was persuaded in 1894 to take it over for conversion to a West End Branch. For over sixty years the library maintained there a fine collection of Judaica, extensively used by the residents of neighboring tenements.

An unfortunate project of urban renewal, initiated in 1958, demolished nearly everything in the West End, converting it into a region of state office buildings and tall apartment towers. In the course of this metamorphosis, a new West End Branch Library was built, and the West Church returned to use by a Methodist congregation. Its neighbors are now exclusively of the twentieth century save for the adjacent first Harrison Gray Otis house across Lynde Street, the only surviving Bulfinch mansion in the West End. Today it is the headquarters of the Society for the Preservation of New England Antiquities, which maintains it handsomely as a worthy neighbor to the Old West Church. As the Otis house when purchased by the society in 1916 was obscured by unsightly additions, it was, for obvious reasons, not included in Rudolph Ruzicka's earlier engraving.

IV

A Corner of Louisburg Square,
Beacon Hill, Boston, 1915

When the West End began to develop into an elegant resi-
dential district, the south slope of Beacon Hill was upland
pasture, largely owned by the painter John Singleton Cop-
ley. It was not long to remain in that rustic state, for the
growing town was beginning to feel a shortage of land
within the limited confines of the peninsula on which it was
situated. In May 1795 the heirs of the late Governor John
Hancock sold his pasture on Beacon Hill above Boston
Common as a site for a new State House. The cornerstone
was laid on 4 July 1796 and in January 1798 the new build-
ing, designed by Bulfinch, was occupied. Moving the seat
of government into the country in the 1790's inspired the
same kind of real estate speculation that rumors of pro-
posed routes of interstate highways do today. Once talk of
the new State House was in the wind, an alert syndicate of
Bostonians calling themselves the Mount Vernon Propri-
etors undertook to buy John Singleton Copley's Beacon
Hill land. Copley, having lived in England since 1774,
knew little of what was going on in Boston and readily
sold, although he subsequently repented of the bargain, un-
successfully. So streets were soon laid out on the southern
slope of Beacon Hill: Beacon Street, running along the
edge of the Common, and parallel to it, Chestnut, Olive
(later Mount Vernon), and Pinckney Streets, further up
the hill. Some of the earliest houses in this new develop-

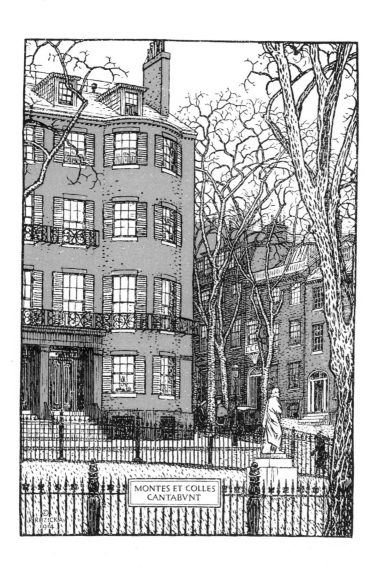

MONTES ET COLLES
CANTABVNT

ment were, like 85 Mount Vernon Street, designed as free-standing mansions, with driveways and gardens. That Bulfinch house—today the handsomest in Boston—was built in 1800 when Harrison Gray Otis, one of the Mount Vernon Proprietors, wished to move from the West End to the site of his adventure in real estate. It soon became clear that land was too scarce to permit such elegancies as a general rule. Consequently most of Beacon Hill was developed in the more economical format of row houses, built close to the street, sharing party walls with their neighbors and with only back yards as open space.

This pattern reached its most pleasing form in Louisburg Square, which, although planned in 1826 by the surveyor S. P. Fuller, gradually built up only in the decade following 1834. The name, which appeared on Fuller's plan, clearly commemorates the provincial campaigns against the Cape Breton fortress of that name, although no anniversary of the sieges of 1745 or 1758 bears any relation to the history of the square. But as Samuel Eliot Morison explained fifty years ago to the historian of Beacon Hill, Allen Chamberlain: 'Paris has its Place des Victoires, its Rue des Pyrénées, and London its Waterloo Bridge. Why not Boston its Louisburg Square?' It is useful to remember Chamberlain's remark: 'Although correct orthography demands the French spelling of the name, no Hillite would presume to speak it otherwise than after the Yankee Provincial manner of "Lewisberg".'

Louisburg Square is an irregular rectangle, extending between Mount Vernon and Pinckney Streets. On the east are ten lots, ranging from 24′ to 32′6″ in width and from 78′10″ to 90′8″ in depth, which run uphill. On the west are eleven slightly smaller lots, running downhill. These front on roadways separated by a garden. On the north the square is bounded by row houses on the north side of

Pinckney Street; the opposite end is formed by houses on the south side of Mount Vernon Street. No uniform design was imposed. Lots were sold to be built on as the buyers pleased. Several lots were bought by contractors who built upon them for speculative sale. The first house was begun in the late summer of 1834. Ten years later, when all but three lots were occupied, the Proprietors laid out and fenced a garden between the roadways of the square, to which in 1850 Joseph Iasigi, the owner of number 3, gave small Florentine marble statues of Aristides the Just and Christopher Columbus.

Louisburg Square is a modest building development of the second third of the nineteenth century without any great architectural pretensions. Yet its scale is so pleasing, its red brick houses so congenial to one another, that it is perhaps the best-loved single street in Boston. The engraving of numbers 1 and 3, with Mount Vernon Street houses beyond Aristides the Just, appropriately bears the Vulgate text of part of Isaiah 35:12, which in the less concise words of the King James version becomes: 'The mountains and the hills shall break forth before you into singing.' Mr. Ruzicka tells me that in choosing the text Mr. Updike had in mind the custom of Christmas singing and visiting on Beacon Hill, which in 1914 was still conducted with neighborly decency.

V

A View of Beacon Hill from the
West Boston Bridge, 1921

In 1630, during the Atlantic passage of the Massachusetts
Bay Company in the *Arbella* to New England, Governor
John Winthrop wrote a lay sermon. Said he in *A Modell of
Christian Charity*: 'Wee must Consider that wee shall be as
a Citty upon a Hill, the eies of all people are upon us.' Win-
throp's company strengthened the image by the choice of
the hilly Boston peninsula for the site of their 'Citty.'
Nearly three centuries later, this view of Beacon Hill across
the Charles River Basin suitably bore the text from the Ser-
mon on the Mount in Matthew 5:14, 'A city that is set
upon a hill cannot be hid.' This engraving I reproduced in
1959 as the frontispiece of my *Boston, A Topographical
History*. Sharing the fondness of Messrs. Updike and Ru-
zicka for Latin titles, I hankered to call the book *Supra
montem posita*. The late Thomas J. Wilson, Director of the
Harvard University Press, rightly would have none of it,
and supplied the title that has kept the work on booksel-
lers' counters longer than most. I have always had a singu-
lar affection for this engraving, for it shows Boston as I
early saw it, coming from Cambridge as a child. In 1921
the silhouette of Beacon Hill was still appropriately domin-
ated by the gold dome of the State House. The seat of gov-
ernment still commanded this view, just as the spires of
churches were the only things that punctuated the skyline
18 above the uniform cornices of Back Bay houses. Today a

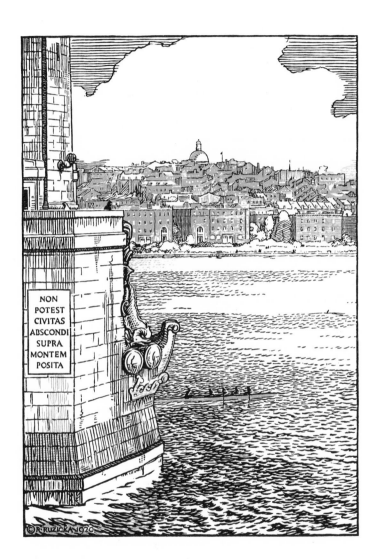

NON
POTEST
CIVITAS
ABSCONDI
SUPRA
MONTEM
POSITA

variety of towers containing government offices, banks, and the Lord knows what diminishes the supremacy of the State House dome from this and from many other points of view. The 'edifice complex,' with its corollary of feeling that one must be at least a little taller or newer than one's neighbor or competitor, has diminished the character of Boston as of most other cities. It is sad that grown, and supposedly responsible, men should be so childish.

The first bridge that linked the Boston peninsula to the mainland was completed in 1786 across the Charles River at the point where a ferry from the North End had plied to Charlestown from the beginning of the settlement. The success and convenience of this toll bridge led in 1793 to the construction of a second one across the Charles from the west end of Cambridge Street to the opposite shore in Cambridge, near what is today known as Kendall Square. This West Boston Bridge was a major undertaking, for the river here was more than twice as wide as at the site of the earlier bridge. The present span, which appears in the left of the engraving, was begun in 1900, from the designs of Edmund March Wheelwright, and completed in 1907. It is the most graceful and handsome of Boston bridges. The piers are of granite. In the center are four towers, suggesting in their design the shape of Georgian silver pepperpots; at each end are two lower and simpler towers. The bridge is 109 feet wide, with two roadways, between which space was provided for the tracks of future rapid transit trains. This space came into use when the subway line from Park Street to Harvard Square was opened on 23 March 1912. The name of the bridge has varied over the years. When it was opened it was generally called the New Cambridge Bridge, although many Bostonians still used the older name of West Boston Bridge, as did Mr. Updike in the title of this keepsake. Although in 1927 the name was officially

changed to Longfellow Bridge, the older name is still often heard.

The completion in 1910 of a dam to the eastward of the bridge excluded the harbor tides, thus converting the Charles River Basin into an agreeable body of fresh water. This major improvement eliminated the mud flats that twice daily had made unsightly the view from the rear windows of Beacon Street houses. It also led to a more handsome use of some of the land between the river front and Charles Street. Between Revere and Cambridge Streets there had long been a coal and wood yard and a gas works, which were supplied by coasting schooners. When the dam eliminated this form of river traffic, there were built on this land two groups of attractive row houses that continued the architectural tradition of Beacon Hill into the present century. Charles River Square, a group of red brick houses surrounding a U-shaped courtyard, was built on the site of the coal and wood yard in 1909 from the designs of Frank A. Bourne, while nearer the bridge in 1916 J. Randolph Coolidge, Jr., of the firm of Coolidge and Carlson, built West Hill Place, in which some houses front on the river and others on a circular courtyard. These are the groups that appear on the river front in this engraving.

A View of Charles Street Church, Boston, as Lately Restored, 1922

From Charles River Square and West Hill Place the intersection of Charles and Mount Vernon Streets is only two blocks to the southward. The same point is only two blocks to the westward, downhill, from Louisburg Square. When the Mount Vernon Proprietors began their work of transforming Beacon Hill into orderly house lots in 1799, they cut down the western peak of the Trimountain by fifty or sixty feet in order to obtain more salable property. Even before the days of bulldozers, real estate promoters succeeded in imposing uniformity on the landscape in hope of gain. This western peak of the hill that overshadowed Boston Common was politely known as Mount Vernon. More realistically, even on maps, it was designated as Mount Whoredom, for on the north slope of Beacon Hill in the late eighteenth and early nineteenth centuries were such houses of ill repute and assignation as the town afforded. Also nearby in modest wooden houses lived the barbers, waiters, and musicians who were listed in an appendix to the earliest Boston directories under the heading of 'Africans.' This was one side of Beacon Hill. The area being developed by the Mount Vernon Proprietors was another. Pinckney Street was the frontier between the two worlds.

In the summer of 1799 a gravity railroad was set up on the western slope of Beacon Hill by which cars of dirt slid down an inclined plane, thus moving the peak of Mount

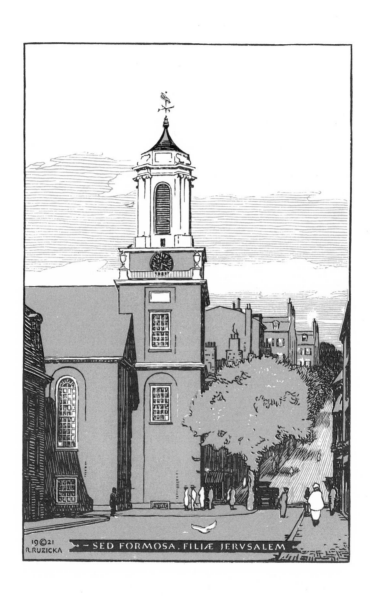

19○21
R.RUZICKA

— SED FORMOSA. FILIÆ JERVSALEM

Vernon into the Charles River to make more land for the Proprietors to sell. This first Boston instance of cutting down the hills to fill in the coves was said by Harrison Gray Otis 'to have excited as much attention as Bonaparte's road over the Alps.' As a result of this activity Charles Street was created in 1805. On the northwestern corner of Mount Vernon and Charles Street was soon built for the third Baptist society, constituted in 1807, the church depicted in this engraving. The architect was Asher Benjamin, who had built the West Church the previous year. The site beside the Charles River facilitated baptism by immersion, but when Cochituate water was brought into Boston in 1848 it was piped into the church to permit administering the sacrament indoors. Some sixty years ago a Civil War veteran, Major William Henry Alline, told me how on the occasion of the first use of the new tank the water failed to flow because he and other enterprising Beacon Hill small boys had mischievously plugged the water pipe.

The text of this engraving, SED FORMOSA, FILIAE JERUSALEM, is a quotation of the third to sixth words of the Song of Solomon 1:5. As the Baptists in 1876 sold the property to the African Methodist Episcopal Church, the building itself exemplifies the first two words of the verse, NIGRA SUM. 'I am black but comely, O ye daughters of Jerusalem.' Sixty years ago anyone walking up Mount Vernon Street from the river at noon on a summer Sunday heard snatches of varied music. In the Church of the Advent, on the corner of Brimmer Street, a *Gloria in excelsis* was being sung. From the firehouse at River Street one might hear ragtime beaten on an old piano, while from the windows of the Charles Street Church floated Gospel hymns superbly sung by fervent black Methodists.

In 1920, as a first concession to the automobile, the city undertook to widen Charles Street by ten feet. While many

24

houses on the western side of the street were sliced off to that extent and provided with new fronts, such an operation could not be performed on the church without completely destroying its symmetry. Although the damages awarded by the city were inadequate, the members of the African Methodist Episcopal congregation, aided by white neighbors who loved the building, raised the funds necessary to move the entire church ten feet westward. Frank A. Bourne, the architect of Charles River Square, who lived diagonally across the way at 130 Mount Vernon Street, helped greatly in the successful completion of the operation, which saved a greatly loved landmark. It was in honor of this act of preservation that Mr. Updike, who lived around the corner in Brimmer Chambers at 112 Pinckney Street, chose the Charles Street Church as the subject for his 1922 greeting.

By the 1920's most of the black congregation, having moved from the north slope of Beacon Hill to Roxbury, were at an inconvenient distance from their church. As the Swedish Mission Church of St. Ansgarius in Roxbury was without a congregation, a group of Beacon Hill residents organized the Charles Street Meetinghouse Society, which purchased St. Ansgarius for the African Methodist Episcopal society, and has for the past half century, not without difficulty, maintained the Charles Street Church for a variety of civic and religious community uses.

A View of Some Old Gardens,
Beacon Hill, Boston, 1931

On the summer day when I first went to the observation platform of the Prudential Center Tower, I was struck by the richness of the green mantle of leaves that covered large portions of the South End, Back Bay, and Beacon Hill. One readily sees a profusion of trees on Boston Common, in the Public Garden, and along the Commonwealth Avenue Mall, but only from the recently created height of the Prudential is one aware of the great number that flourish, hidden from the sidewalks, in the back yards and gardens of row houses in the center of the city.

Some of the green mantle is furnished by the *Ailanthus*, a fast-growing tree which volunteers its services in the most improbable places. It is of Chinese origin, otherwise known as the Tree of Heaven; appropriately so because its branches seek the sky with remarkable speed. It seeds itself in places where nothing else will grow. Years ago an effort was made to grow something in the narrow space between the façade of the Boston Athenaeum and the Beacon Street sidewalk. Loads of loam were brought in; the wise Arthur A. Shurcliff gave advice about planting; the staff watered, yet nothing thrived. Finally the loam was removed and the narrow area cemented over as one unsuitable for any living thing. Thereupon three *Ailanthus* trees seeded themselves and have grown with enthusiasm. They were not what was wanted, or intended, but I never had the

26

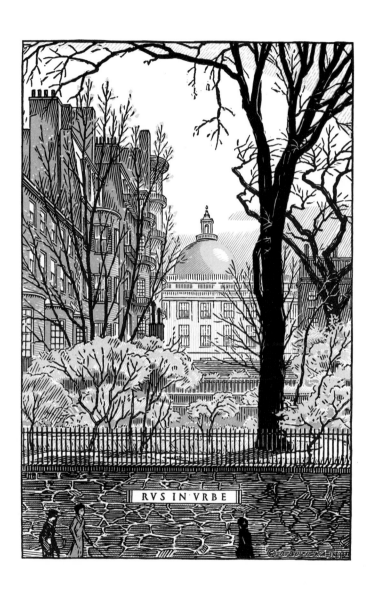

RVS IN VRBE

heart to cut them down. I did, however, twenty years ago have to remove an *Ailanthus* that chose to grow out of the retaining wall between 87 and 85 Mount Vernon Street, for its roots were on the way to pulling the wall down. This stalwart volunteer is by no means the only tree shading Beacon Hill gardens: in the one shown here the ground is more propitious to arboriculture than the narrow plot in front of the Boston Athenaeum.

The Beacon Hill garden that Rudolph Ruzicka chose to illustrate the Virgilian sentiment of country in city is that of 14 Walnut Street, which was at that time the home of Ellery Sedgwick, editor of the *Atlantic Monthly*. The house, which does not show in the engraving, is one of the earliest on Beacon Hill, for John Callender, Clerk of the Supreme Judicial Court of the Commonwealth, bought this lot at the corner of Walnut and Mount Vernon Streets for two thousand dollars in the autumn of 1802 and contracted to construct 'a small house for a little money 5000–7000.' It is not exactly small in today's terms, but it is unlike most of its neighbors on Beacon Hill in that, although of brick, its north façade along Mount Vernon Street is sheathed with close-jointed boarding, painted gray. It therefore has a more rural aspect than its later neighbors, a situation enhanced by its garden, which is terraced above the sidewalk of Walnut Street by a sturdy granite retaining wall. This difference in grade gives substantial privacy. Beyond this garden is a considerable open space totally invisible from the street formed by the collective back gardens of adjacent houses on Walnut, Mount Vernon, and Joy Streets. This network of gardens permitted, in the spring before the trees leaved out, the view through to the dome of the State House.

This dome has not always been gold. When the building was completed in 1789 from Charles Bulfinch designs, it

was an oblong structure of red brick, 173 feet wide and 61 feet deep, with a basement story 20 feet high, and a principal story 30 feet high. In the center of the front was an attic 60 feet wide and 20 high, crowned by a pediment, above which rose a dome 50 feet in diameter and 30 feet high. Although the circular lantern that crowned the structure was surmounted by a gold pinecone, the dome as built was shingled and whitewashed. Paul Revere and Sons covered the dome with copper in 1802; for many years thereafter it was painted 'stone-color,' until in 1861 it was painted gold. For the past century it has been resplendent in gold leaf, save for eclipses during two world wars when, for fear of enemy aircraft, it was camouflaged in battleship gray. Whenever the State House has been enlarged, successive architects have echoed Bulfinch's forms but invariably used different materials that were currently fashionable. When Charles Brigham added the northern extension in 1889–1895 in yellow brick, Bulfinch's red brick was painted to match. When white marble wings were added to the east and west in 1914–1917, it was again painted to match. In 1928 the paint was removed: since then the State House has been a bird with a red body, gold dome, white wings, and a yellow tail.

A View of the Granary Burying-Ground Showing Monument to Benjamin Franklin's Parents and Park Street Church, 1923

This engraving has a particular poignancy for me as it crystallized the view that I saw daily from the windows of the Boston Athenaeum during the years from 1946 to 1973 when I was its Director and Librarian. Summer or winter the view was a delight from any floor of the library. From my fourth-floor office I particularly enjoyed looking into the tops of the trees when the leaves were first bursting out in their fresh green. And the presence of this open space ensured full morning sun on all floors of the Athenaeum in a manner that one normally could not expect in the center of a crowded city.

The view encompasses three centuries of Boston history. As the burying ground itself, the third oldest in the city, was carved out of Boston Common in 1660 to serve the central area and the old South End, it was at first known as the 'New,' the 'South,' or the 'Common Ground.' The present name dates from 1737 when the town Granary, first built in 1729 on the Common near the present subterranean public toilets, was moved to the site of the Park Street Church. The Granary was a wooden building used for storing the twelve thousand bushels of grain annually pur-

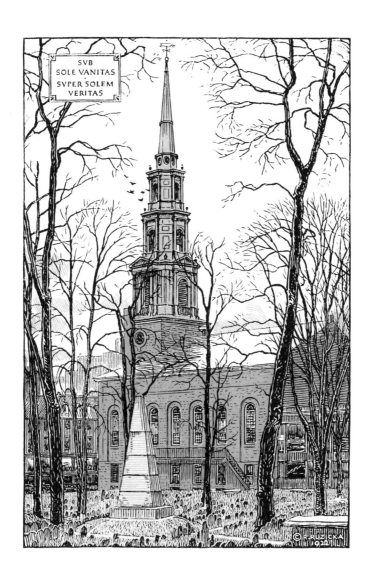

SVB
SOLE VANITAS
SVPER SOLEM
VERITAS

chased by the town for sale to the people at only a small advance over the wholesale price. Eighteenth-century Park Street, which was far out of town, facing the Common, was a logical situation not only for the Granary but for the Almshouse, the Workhouse, and other odds and ends of municipal institutions. With the completion of the new State House directly above, the situation rapidly changed. Town service buildings were relocated in less conspicuous sites. After a new Almshouse in Leverett Street had been built in 1801, the Park Street land became available for the construction of private houses. In 1804 Thomas Amory built at the corner of Beacon Street a square brick house that still stands, although much altered. The following year a row of handsome four-story brick houses, designed by Charles Bulfinch, was begun lower down the street; these, alas, have disappeared. The transformation of Park Street was completed in 1809, when the large Granary at the lower end was removed and replaced by the present church.

The Park Street Church was established as an orthodox Congregational reaction to the growing Unitarianization of Harvard College. The fervor of Orthodox doctrine preached within its walls led to the corner of Tremont and Park Streets being known as Brimstone Corner. The windiness of the corner is attributed to a gale of wind coming along one day in the company of the Devil. The latter went into Park Street Church with the intention of rescuing some of his followers. As he was vanquished by the potency of Calvinist fervor, he never emerged; his companion still awaits him. However severe the doctrine preached within, the exterior of Park Street Church is one of the aesthetic delights of Boston. Its English architect, Peter Banner, designed a singularly graceful steeple which dominates this end of Boston Common. Although new tall buildings com-

pete unfortunately with it from some angles, the steeple still watches over the Granary Burying Ground as it did more than fifty years ago when Rudolph Ruzicka engraved this view.

In the burying ground rest the diarist Judge Samuel Sewall, Peter Faneuil, and John Smibert, the architect of Faneuil Hall. Here lie governors, both colonial and of the present Commonwealth, the victims of the Boston Massacre, and such effective revolutionists as Samuel Adams, James Otis, Paul Revere, and John Hancock. The central and most conspicuous monument, however, marks the grave of a modest tallow chandler and soapmaker, who died in 1744, aged eighty-nine, and his wife, who outlived him by eight years. Their inscription reads: 'Josiah Franklin and Abiah his wife lie here interred. They lived lovingly together in wedlock fifty-five years, and without an estate, or any gainful employment, by constant labor and honest industry, maintained a large family comfortably, and brought up thirteen children and seven grandchildren respectably. From this instance, reader, be encouraged to diligence in thy calling, and distrust not providence. He was a pious and prudent man; she was a discreet and virtuous woman. Their youngest son, in filial regard to their memory, places this stone.' When in 1827 the original inscription had become nearly obliterated, the couple's youngest son, Benjamin, was so venerated that a group of citizens of Boston placed a twenty-one-foot obelisk of Quincy granite over the grave, making it the focal point of the burying ground, and reproduced the epitaph in more permament form 'as a mark of respect for the illustrious author.'

IX

Christ Church, Salem Street, Boston, Looking West from 'The Prado,' 1936

Christ Church, Salem Street, the 'Old North Church' of Henry Wadsworth Longfellow's 'Paul Revere's Ride,' is known to countless thousands of Americans because of the signal lanterns hung in its steeple on the night of 18 April 1775. But there are many Bostonians who are unaware that this is the oldest church in their city, and that, notwithstanding the pilgrims of history, the Book of Common Prayer has been used within its walls for more than two and a half centuries of unbroken religious continuity. The power of quotable and easily remembered verse concerning a few hours of a single evening has to a remarkable extent obscured the greater religious and architectural significance of this ancient and graceful structure.

The Church of England penetrated Boston only in company of Sir Edmund Andros, the first royal governor of the Massachusetts Bay province. The King's Chapel that he built in 1688 in the center of the town was the modest predecessor of today's mid-eighteenth-century church of that name at the corner of Tremont and School Streets. Of the Puritan Congregational churches of Boston, the first was in the center, near the Town House; the second, founded in 1660, was in the North End, while the third, gathered in 1669, was in the South End. As the Church of England waxed, the creation of new Anglican parishes followed a similar geographical pattern. So in 1723 Christ Church was

34

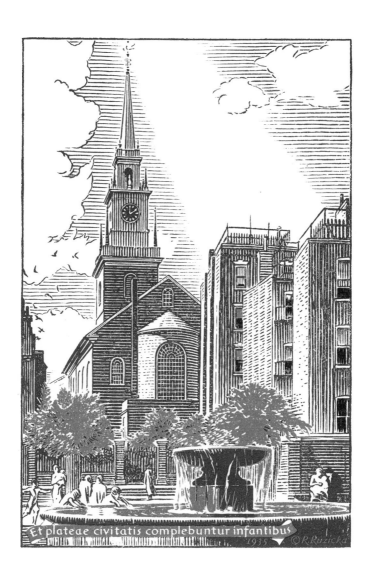

Et plateae civitatis complebuntur infantibus
1935 ©R.Ruzicka

established in Salem Street in the North End, while Trinity, the third parish, founded in 1733, was located in Summer Street in the South End. But of the half-dozen religious bodies just named, Christ Church alone has remained in its original building.

The going was not always easy, especially as successive waves of newcomers of other faiths—first the Irish, then central European Jews, and finally Italians—took over the North End. Early in the twentieth century when only a handful of local parishioners remained, William Lawrence, Bishop of Massachusetts, created a new congregation by persuading friends from other parts of Boston to buy pews in the historic church, and became rector himself. With his customary energy, Bishop Lawrence raised funds for the restoration of the church to its eighteenth-century appearance. It was rededicated on 29 December 1912, the 189th anniversary of the first service.

High box pews fill the body of the church. Above the center aisle hang a pair of English brass chandeliers, a gift from an original parishioner, that were first lighted on Christmas Day 1724. In the north aisle, near the lofty pulpit, the handsomely upholstered 'Bay Pew' was set aside 'for the use of the gentlemen of the Bay of Honduras who have been or shall be benefactors of the Church' in courteous acknowledgment of gifts of logwood from that colony that had helped to build the church steeple. On three sides of the church are galleries. The lateral ones are fitted with pews; in the western one, devoted to the choir, is a fine eighteenth-century organ case, before which stand on pillars four polychromed Belgian Baroque angels blowing trumpets, captured in 1746 by a seafaring parishioner from a French ship bound for Quebec. When the graceful wooden spire, added to the top of the tower in 1740, blew down in a hurricane in 1804, it was rebuilt in slightly different form,

fifteen feet shorter, from designs of Charles Bulfinch. When that in turn fell in a 1954 hurricane, Charles R. Strickland modelled the present replacement on William Price's original design of 1740.

During the nineteenth century, as thousands of new-comers from Europe crowded into the North End, Christ Church became surrounded by unsightly tenements. To alleviate the fire hazard, the city of Boston began in 1933 to demolish a number of them from the rear of the church at Unity Street through to Hanover Street. By use of the George Robert White Fund, the city set up benches and a fountain and brick walls, bearing bronze tablets recalling the history of the North End, which enclose a pleasant paved open space. On fine days, this is occupied by Italian residents of the North End. Children play (as the text of Zechariah 8:5 suggests); their elders chat or play cards with an animation that recalls a Mediterranean square. The North End, thanks to its Italian residents, is one of the liveliest parts of Boston; it is also the only part of the city in which people have lived continuously since the 1630 settlement.

The open area when first created was incongruously known as 'The Prado.' As a Spanish name made no sense in an Italian neighborhood, the name was changed in 1940 to the Paul Revere Mall when Cyrus E. Dallin's equestrian statue of Revere, modelled in 1885, was at last cast and installed there between the fountain of this engraving and Hanover Street.

X

Saint Stephen's Church
on Hanover Street, Boston,
Looking East from 'The Prado,' 1937

In this engraving the surroundings of the fountain of the Paul Revere Mall present an even more animated scene than in the one of the preceding year. In no other instance in the series did Rudolph Ruzicka create a pair of views from a single site, looking in different directions. There is, however, no other open space in Boston that has such remarkable churches at its two extremities. While Christ Church, Salem Street, is the most ancient religious edifice in Boston, St. Stephen's, Hanover Street, although eight decades younger, is the only church designed by Charles Bulfinch to have survived in the city: hence the Updikean whimsy PYRRHULAE OPUS, *Pyrrhula* being the Latin name for a bird called bullfinch in English.

Between 1788, when he began to practice architecture, and 1818, when he moved to Washington to become Architect of the Capitol, Charles Bulfinch literally changed the face of Boston. He designed the State House, Court House, Faneuil Hall, a theatre, concert hall, five banks, four insurance offices, three schools, two hospitals, four churches, three entire streets, and a considerable number of private houses. These were the years when, as chairman of the Board of Selectmen, he was also the principal officer of government in Boston. When one ponders this list one appre-

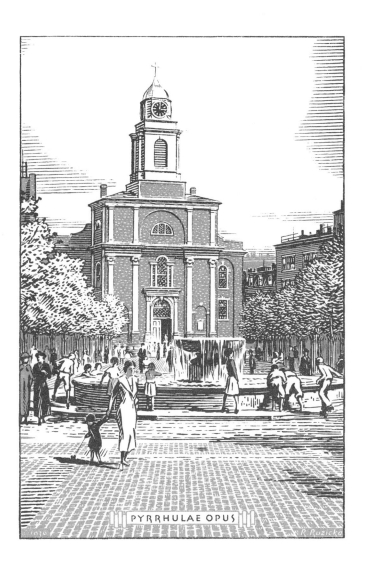

PYRRHULAE OPUS

ciates the anecdote recalled by Bulfinch's granddaughter: when 'asked if he should train up any of his children in his own profession, he replied, with charming naïveté, that he did not think there would be much left for them to do. The States and towns were already supplied with their chief buildings, and he hardly thought a young man could make a living as an architect.' Subsequently many less able men, young and old, have done so because of the American passion for knocking buildings down and starting over. Alas, only a fraction of Charles Bulfinch's work in Boston has survived this pernicious national sport.

The Church of the Holy Cross in Franklin Street that he designed in 1800 for Father Cheverus (later the first Roman Catholic Bishop of Boston) was demolished in 1862. The brick Gothic Federal Street Church that he built in 1809 for William Ellery Channing's Unitarian followers was knocked down in 1859 when the congregation moved to Arlington Street in the new Back Bay. His most beautiful church, the New South, built on Church Green at Summer and Bedford Streets in 1814, was demolished in 1868. Only his New North in Hanover Street survives, and that under another invocation. The cornerstone was laid on 23 September 1802 and the building dedicated on 2 May 1804.

The interior of the New North was almost square—70 feet long and 72 feet wide—with lateral galleries having rows of Doric columns below and Corinthian columns above, which rose to a low arched ceiling. The west front was decorated with pilasters, and surmounted by a cupola. From 1813 until 1849 the Reverend Francis Parkman, father of the historian, served as pastor of the New North Church. By 1822 the congregation was suffering from the social fading of the North End. A historical sketch of that year noted that 'the young gentlemen who have married wives in other parts of the town have found it difficult to

persuade them to become so ungenteel as to attend worship at the North End, while the ladies of the society, as they have become wives, have affected it a mark of taste to change their minister.' Indeed Mr. Parkman during his pastorate preferred to live in the region of Bowdoin Square in the West End. The days of the New North were numbered because of changes in population.

When the end came in 1862, Bishop Fitzpatrick bought the building and gave it new life as St. Stephen's Roman Catholic Church. In the course of the next century it went through a series of metamorphoses. About 1870 when Hanover Street was widened, it was moved back twelve feet. Soon after, when it became too small for its fast-growing Irish congregation, it was raised six and a half feet to insert a lower church beneath. Finally in 1964 Richard Cardinal Cushing, Archbishop of Boston, in the course of a major restoration, lowered the church to its original level, using the same firm, Isaac Blair & Co., that had jacked it up for Archbishop Williams some ninety years earlier! The interior was brought back to a simplicity that would have delighted the original congregation, while the cupola was restored to its original form from the awkward alteration shown in this engraving. By this admirable restoration of Bulfinch's only surviving church in the city, the late Cardinal Cushing made an important contribution to the architectural amenities of Boston, for which we are all grateful.

A View of the Frog Pond,

Boston Common, 1935

When the settlers of the Massachusetts Bay Company ar-
rived in 1630, the sole inhabitant of the peninsula on which
they established Boston was an eccentric bachelor Anglican
clergyman with a hermit's taste for his own company. The
Reverend William Blaxton, a Master of Arts of Cambridge
University, had come to New England in 1623 as chaplain
of an abortive attempt at colonization at Wessagusset
(now Weymouth), led by Robert Gorges. When this plan-
tation broke up, Blaxton, in lieu of returning to England,
wandered north, settling in 1625 on the western slope of
what is now Beacon Hill. Having found an excellent spring,
he built a house, planted an orchard, and enjoyed minding
his own business, undisturbed in the wilderness, for five
years. Blaxton received the Massachusetts Bay Company
with more civility than enthusiasm. Eventually finding his
new neighbors too much of a good thing, he moved off to
Rhode Island, but not until he had sold the close to fifty
acres of Boston Common to the town for thirty pounds.

The Common, which was to the south of the Trimoun-
tain, ran down on the west to the Back Bay of the Charles
River, a tidal inlet that alternated between being a body of
water and mud flats. The seventeenth-century settlement,
nestling close to the harbor, was well away from this open
space where cattle were pastured, militia companies drilled,
and children played. This was where, as John Josselyn, a

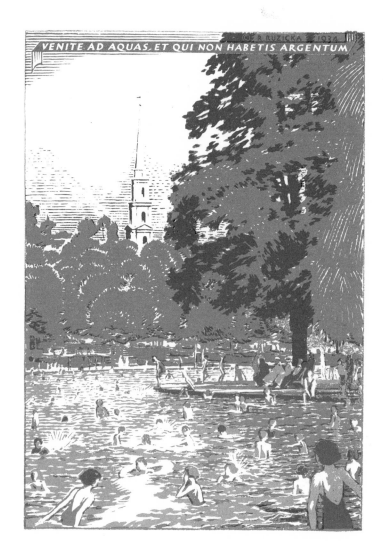

seventeenth-century English visitor, observed, 'the Gallants a little before Sun-set walk with their Marmalet-Madams, as we do in Morefields, &c till the nine a clock Bell rings them home to their respective habitations, when presently the Constables walk their rounds to see good order kept, and to take up loose people.' As we have seen earlier, odds and ends of municipal institutions were placed along the Park Street side of the Common during the eighteenth century. On the Tremont Street side were the Hay Scales and similar rusticities.

The Common's only body of water, the Frog Pond, was originally a modest puddle with shelving banks from which boys fished and cows drank. It is alleged that enlisted men from the French fleet during the Revolution proved their nationality by hunting there for frogs. As Beacon Hill built up and as handsome rows of Bulfinch houses transformed Park and Tremont Streets from country to town, the Common became less rural. Its shores were curbed in 1826 and in 1830 cows were banished from the vicinity of the Frog Pond. But boys still fished and skated and sailed toy boats there.

The apotheosis of the Frog Pond occurred on 25 October 1848, when it was the center of the celebration of the piping of Cochituate water into the city. After an impressive parade through the streets, the mayor and other dignitaries took their places on a platform over the middle of the pond. A pipe brought into the pond was opened; a fountain of Cochituate water shot into the air. James Russell Lowell's Ode beginning 'My name is Water' was sung; church bells rang, cannon were fired, and wild huzzas shouted in honor of the event. The scene was commemorated in a lithograph which indicates that there was hardly a spot on the Common free of celebrators, military companies, children, and dogs. But this great event meant that the Frog Pond was

no longer an independent body of fishable water; it had become part of the municipal system. So it was only a matter of time before the pond was paved, and made capable of being drained and refilled at the choice of a city employee.

It is perhaps just as well, so far as public health is concerned, for the Frog Pond has become the summer wading and splashing place of thousands of small children. They arrive in droves, leave their clothes with a friend or relative on the grass, and plunge in, with the happy excitement Rudolph Ruzicka has depicted in this engraving. The fragment of Isaiah 55:1 chosen for the text admirably fits the scene: 'Come ye to the waters, and he that hath no money.' In the background the steeple of Park Street Church is silhouetted against the sky. This, however, was 1935; today the sky would be disputed by some tower or other. But the scene in the pond has changed little with the passage of forty years. It remains a favorite resort of children on a murderously hot Boston summer day.

XII

The Washington Monument
in the Public Garden, Boston, 1934

The Public Garden is separated from Boston Common only by Charles Street. Yet they were until recently quite different worlds. In the Frog Pond children splash in summer; on the artificial lake in the Public Garden they ride in swan boats. This *opéra bouffe* type of craft consists of a row of floating benches mounted on pontoons, pedalled through the water by a relative of a bicycle concealed in an artificial swan at the stern. The Common has trees and grass but until recently no flowers; today the rectangular brick boxes of bedding plants along the Tremont Street mall still seem an artificial innovation. The Public Garden's numerous ornamental trees and shrubs and beds of brilliant plants preserve a taste more reminiscent of nineteenth-century municipal gardens in Scotland and France than appealing to twentieth-century American garden club members. Bums and sailors with time heavy on their hands gravitated toward the Common; mothers or nursemaids with tidy children passed their time in the Public Garden, sitting on benches rather than the grass. Or so it was until the sprouting of hippies, who blurred most unwritten rules of behavior as well as dress.

The Public Garden is on land gradually reclaimed from the Back Bay under circumstances both accidental and curious. When cumbersome ropewalks between Pearl and Atkinson Streets in the South End burned on 30 July 1794,

the town granted the owners the right to build replacements on the marshy flats at the foot of the Common, provided they erected a seawall to protect the site. The ropemakers gratefully accepted. Thirty years later, when Boston was beginning to grow to the westward, it was clear that by attempting in 1794 to get an unsightly nuisance out of the way, the town had made a bad bargain. Consequently, in 1824, at Mayor Josiah Quincy's instigation, the land was repurchased for the large sum of $55,000, after which it was determined that it should be 'forever after kept open and free of buildings of any kind, for the use of the citizens.' Horace Gray and other amateur horticulturists in 1837 conceived the idea of developing the area as a botanic garden. Although ornamental trees and plants were set out, certain members of the City Council, greedy for gain, attempted unsuccessfully in 1842, 1843, 1849, and 1850 to sell the garden for building lots! Finally in 1856, when plans for the filling of the entire Back Bay were being concerted, Arlington Street was established as the western boundary of the Public Garden, and these twenty-four acres dedicated forever to public use. In 1863 the space was enclosed by an iron fence. When an artificial pond had been created, a miniature suspension bridge was built to span it in 1867, so as to permit a straight path from the Common through the Public Garden to the beginning of Commonwealth Avenue at Arlington Street.

Toward the western end of this path stands Thomas Ball's equestrian statue of General Washington, who appropriately seems about to ride west on the Commonwealth Avenue mall into the setting sun. It was, as I indicated in my *Boston Statues*, only in the second half of the nineteenth century that such monuments began to appear in public places in the city. This was largely the result of a

48

proliferation of New England–born sculptors who, having

studied in Italy, were in need of commissions. Thomas Ball (1819–1911), the son of a Charlestown house and sign painter, went to Florence in 1845 to pursue sculpture. His first commissions were bas-reliefs of the signing of the Declaration of Independence and the Treaty of Paris that adorn the pedestal of Richard Saltonstall Greenough's statue of Benjamin Franklin, erected in School Street in 1856 on the sesquicentennial of Franklin's birth. Some of Ball's friends in Boston organized a Washington Statue Fair in the Music Hall from 16 to 24 November 1859, which raised $10,000 for a proposed equestrian statue. It would be the first man on horseback in Boston, for Sir Francis Chantrey's Washington (in Doric Hall in the State House) was simply a standing figure. Moreover, Sir Francis was an Englishman, for in 1826 no native-born sculptors were available. Now here was Ball, a local son, ready and willing to produce an equestrian monument to the Father of his country. The Civil War, and Ball's absence in Florence, caused numerous delays. Nevertheless the statue was finally cast, shipped, mounted, and dedicated in 1869. Of the total cost of $42,000, only $10,000 was appropriated by the city. All the rest was provided by private subscription and the efforts of Ball's friends.

XIII

Worcester Square Looking Towards the City Hospital, Boston, 1938

General Washington's horse might head toward Commonwealth Avenue, but Mr. Updike ignored the suggestion. Though many of his friends lived there, his series of annual greetings included no view of the Back Bay. He himself occupied bachelor chambers at the foot of Beacon Hill for many years, and only in the last decade of his life moved to a Back Bay house at 338 Marlborough Street. For the year 1938 he chose as a subject a square in the South End, a quarter never frequented by his fashionable friends, who preferred the superior amenities of the Back Bay.

This was a new South End, further south than the colonial area of that name, created in the first half of the nineteenth century by filling land on both sides of the narrow neck that connected the Boston peninsula with the Roxbury mainland. As this new land encroached upon both the South Cove of Boston Harbor on one side and the Back Bay of the Charles River on the other, the neck acquired a goiterous profile. Finally it disappeared altogether, for by the end of the Civil War Washington Street, the old single road to Roxbury, was flanked on made land by parallel thoroughfares—Albany Street, Harrison Avenue, Shawmut Avenue, an extension of Tremont Street, and Columbus Avenue. In the late 1840's it seemed momentarily that this new South End might become a suburb, attractive to persons who wanted rather more space around their houses

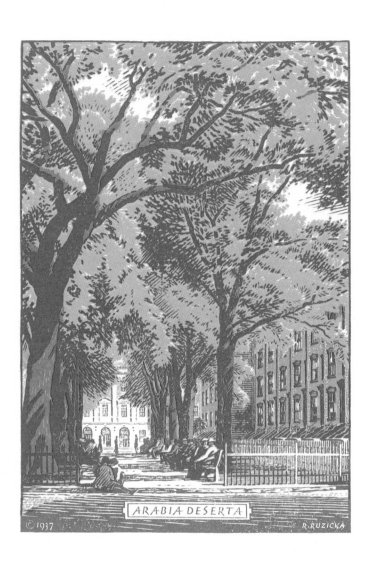

ARABIA DESERTA

© 1937 R. RUZICKA

than was possible in the older parts of the city. As this hope did not materialize, the city in 1850 took steps to develop a varied street plan, with squares and parks that might encourage the building of good-looking row houses. So the land was sold, and streets, avenues, and squares were gradually built up, usually with considerable attention to the architectural unity of the blocks.

By building there, numerous institutions lent stability to the new region. A handsome granite Jesuit Church of the Immaculate Conception was built in Harrison Avenue in 1861; Boston College, administered by that order, was established in an adjacent building in 1863. With the swelling growth of the Catholic population, the Cathedral of the Holy Cross in Franklin Street that Charles Bulfinch had designed for Bishop Cheverus, having become far too small, was sold and demolished in 1860. The diocese bought land in the new South End at the corner of Washington and Waltham Streets, where a vast new Gothic cathedral, of the same dedication, was constructed between 1867 and 1875. Between 1861 and 1864 the Boston City Hospital built a handsome institution in the French Second Empire taste on a seven-acre tract near Boston College, while numerous schools and churches moved to the new region.

Although some South End houses, particularly in Chester Square and East and West Chester Parks (now part of Massachusetts Avenue), were both large and handsome, because of competition elsewhere the region never became fashionable. The new Back Bay, west of the Public Garden, which began to be filled in the late fifties, offered greater attraction to established families who had formerly lived in older parts of the city. The *coup de grâce* to the new South End was given by the panic of 1873. Many distinguished-looking blocks there, built on mortgages, were re-possessed by banks, who sold them for whatever they could obtain.

By 1885 the South End, although still externally handsome, had grown into a region of lodging houses, well on its way to becoming a slum.

Worcester Square, which led from Washington Street to the entrance of the City Hospital, was laid out in 1851, and built up pleasantly and uniformly within a few years. Eighty years later it was still a tree-shaded oval, but one that would only be penetrated by historical or architectural explorers, so far had its original occupancy changed. To me the text ARABIA DESERTA that Mr. Updike borrowed from the title of Charles M. Doughty's great account of desert travel seems one of his better witticisms. In this instance I must side with him rather than the engraver.

In the past twenty years, however, the desert has gradually been reclaimed. With an increasing return to city life, many houses in the South End have been restored, often by imaginative young families. Today the region offers greater attraction and promise than at any time during the past century.

XIV

The Custom-House Tower
from the Waterside, 1920

Four words of Psalm 99:1, 'The Lord reigneth . . . let the earth be moved,' apply to the Boston waterfront with singular aptness, for the site of the Custom-House Tower, though now well inland, was once in the Town Cove that jutted in from the harbor. Walking down State Street from the Old State House, one meets the original shore line at the intersection of Kilby Street, two blocks short of the Custom-House. From 1710, when the construction of the Long Wharf carried the line of State Street well into the harbor, the eventual filling of the Town Cove was simply a matter of time. Bostonians were constantly 'wharfing out' along the varied shores of the peninsula to gain space and create new land.

Early in the nineteenth century, the waterfront north and south of the Long Wharf was transformed through the activities of Uriah Cotting, who incorporated the Broad Street Associates. With Charles Bulfinch as planner, Cotting demolished, filled, and rebuilt, transforming an area of narrow alleys, delapidated buildings, and wharves into one of broad streets and noble brick warehouses. Broad Street was created on made land to run from State, on the harbor side of Kilby, to the head of a superb new India Wharf. Thither India Street ran from the bottom of State along the new harbor front. These parallel new streets were intersected by cross streets, on one of which, Custom-House

54

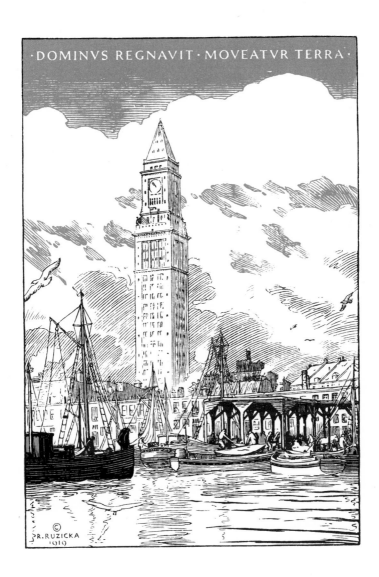

·DOMINVS REGNAVIT · MOVEATVR TERRA·

Street, laid out in 1804, Uriah Cotting designed and built a new Custom-House for the federal government.

When Cotting's structure was outgrown after the passage of thirty years, a new site was chosen for its replacement. This was on the India Street shorefront between State (which led to the Long Wharf) and Central Streets. The latter gave access to Central Wharf, which jutted into the harbor between Long and India Wharves. Ammi Burnham Young in 1838 designed the new Custom-House as a granite Greek temple with Doric porticoes east and west. Completely surrounded by engaged Doric columns, the building was originally surmounted by a low saucer dome on an octagonal drum. Its great scale, the harmony of its design, and its superb use of granite made it one of the great ornaments of the city. Although captious later critics of the Greek Revival have made much of the absurdity of collecting custom duties in a Greek temple whose colonnades obscure the daylight of bookkeepers, this building greatly impressed Young's contemporaries. It doubtless played a part in his appointment as successor to Robert Mills as architect to the Treasury Department, in which capacity he subsequently built countless federal courthouses, custom-houses, post offices, and marine hospitals in various parts of the United States.

When the Boston Custom-House was built it looked directly on the harbor. Its seaward portico could be approached by boat until 1857, when the area between Long and Central Wharves was filled for the construction of the massive State Street Block. Further filling of land in 1868 for the creation of Atlantic Avenue put the Custom-House at even greater distance inland. While this over-optimistic development greatly enlarged the waterfront at the moment when Boston's maritime commerce with distant ports was waning, the Atlantic Avenue wharves for some dec-

ades accommodated coastal shipping and fishing craft. Although the completion of the Fish Pier in South Boston in 1914 drew most fishing vessels to that site, a few still came to Atlantic Avenue to provide an industrious foreground for this engraving.

When Ammi B. Young's Custom-House was outgrown after seventy-five years, it was not demolished but enlarged. The manner of its enlargement was unprecedented in Boston at the time, for the architects Peabody and Stearns substituted for Young's low dome an Italian campanile of an office building, which was Boston's first, and long only, skyscraper. A 125-foot height limit kept the Boston skyline low; only church steeples and the State House dome provided vertical accents. As the Custom-House was federal property, it was exempt from that municipal regulation, so up it went to the amazement of Bostonians. A large four-faced clock, visible from a considerable distance, was a useful amenity, while an observation tower, easily reached by elevator, provided a panoramic view with less effort than climbing Bunker Hill monument on foot. The tower was completed in 1915; that spring the Boston painter A. C. Goodwin (1864–1929) exhibited at the Doll & Richards gallery '18 Oils of Custom House Tower from Different Points of View.'

XV

A View of Bunker Hill Monument, Charlestown, 1916

Here Mr. Updike amended Scripture to suit the New England mentality, adapting Psalm 135:13, 'Domine nomen tuum in aeternum: Domine memoriale tuum in generationem et generationem'—or as the King James version has it, 'Thy name, O Lord, endureth for ever; and thy memorial, O Lord, throughout all generations'—to substitute the name of Bunker Hill for that of the Lord! This was completely in the spirit of the Bunker Hill Monument Association, incorporated in 1823, which undertook a memorial *in excelsis* of the battle of 17 June 1775.

The approaching fiftieth anniversary in 1825 caused a flurry of agitation, for the Association had but two years in which to accomplish something visibly dramatic. Committees recruited members and solicited contributions. Land was purchased, and a cornerstone laying ceremony planned for 17 June 1825 with an address by Daniel Webster, though as yet no agreement had been reached about the type of memorial that was to rise above this cornerstone. Furthermore, newspapers announced that General Lafayette, who had arrived in the United States in August 1824, would lay the cornerstone, long before the Association had thought of inviting him to do so. In January 1825 the Bunker Hill Monument Association invited artists throughout the country 'to furnish plans of whatever character or design for the proposed Monument,' while in April a

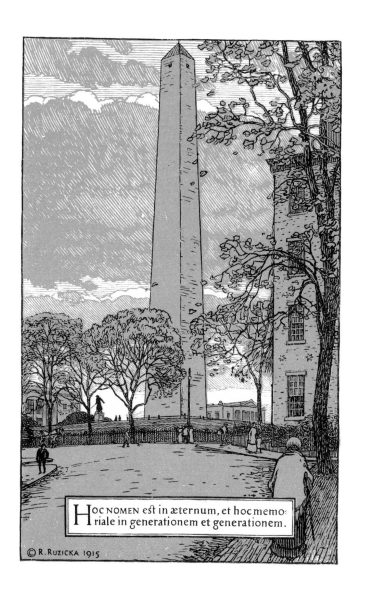

HOC NOMEN est in æternum, et hoc memoriale in generationem et generationem.

© R. RUZICKA 1915

'Board of Artists,' consisting of Daniel Webster, Gilbert Stuart, Washington Allston, Loammi Baldwin, and George Ticknor, was appointed to review the submissions 'and give their opinion about any other plan which may occur to them.' It was indicated that 'a monumental column of about 220 feet in height, to be built of hewn granite,' was what the Association had in mind. Robert Mills, from Columbia, South Carolina, submitted plans for an obelisk, but it was the model of an obelisk by the young Horatio Greenough, then a senior at Harvard College, that received the hundred-dollar premium. When the anniversary arrived, the debate of column versus obelisk was still raging; nevertheless the cornerstone was laid with immense pomp and ceremony, although no one knew what might eventually rise above it or when!

The civil and military procession that assembled on Boston Common was so huge that the first contingent reached Charlestown Square before the last groups had started to march. Venerable veterans of the Revolution joined in it, among them General Lafayette, who was the hero of the occasion. After assisting the Masonic Grand Master with the trowel and mortar, Lafayette refused a seat with the dignitaries on the platform. 'No,' said he, as reported by his aide, Josiah Quincy, Jr., 'I belong there, among the survivors of the Revolution, and there I must sit.' Sit he did, with the veterans, in the hot June sun. Of Daniel Webster's oration, Josiah Quincy, Jr., wrote: 'As America, in the patriotic fervors which had not then been chastened, seemed to tower superior to all other nations, so towered Webster above all other men. What a figurehead was there for the Ship of State! No man, as Sydney Smith said, could be so great as this man looked, and now he looked his very greatest.'

The great ceremony was a fortnight in the past before it

was agreed that the monument should be an obelisk, 30 feet square at the base and 220 feet high; on Halloween 1825 Solomon Willard was chosen as the architect. When he found a quarry of gray granite in the western part of Quincy that provided the ideal material, the first railway in Massachusetts was constructed in 1827 to move stones to a wharf, from which they could be transported by water to Charlestown. By February 1829, when the monument had reached the height of thirty-four feet, work was suspended for lack of funds. In a second effort, between 17 June 1834 and November 1835, the laying of eighteen more courses brought the height to eighty-five feet. There it remained until 1840. Then in September energetic Boston ladies, organized by Mrs. Sarah Josepha Hale, held a week-long fair in the hall above Quincy Market and raised enough money to finish the monument. Work resumed to such purpose that the cap-stone of the obelisk was laid on 23 July 1842. The completion was celebrated on 17 June 1843 at a ceremony, graced by the presence of President John Tyler, thirteen survivors of the battle, and ninety-five other Revolutionary soldiers, at which Daniel Webster gave an oration that surpassed even his address of 1825. The monument remained the most grandiose memorial in the United States until 1885, when the 555-foot Washington Monument, designed by Robert Mills, was dedicated in the nation's capital.

A View of Fort Independence
on Castle Island, Boston Harbor, 1933

In my childhood Castle Island still kept its traditional in-sularity, for one approached it by a 900-yard-long wooden footbridge from the low promontory City Point, the most easterly part of South Boston. With the filling of land and the construction of the Army Base, Castle Island has be-come firmly attached to the mainland. Once there, how-ever, the massive granite walls of Fort Independence dom-inate the scene. It has suffered nothing comparable to Gov-ernor's Island, a mile across the ship channel leading to the Boston waterfront, which was the site of Fort Winthrop; today both that island and fort have vanished under the runways of Logan International Airport. Around 1910, when I was first taken to Castle Island, war was indeed sweet to those who knew nothing of it. I found the ram-parts of Fort Independence an incredibly romantic place to play soldier, as children of 1932 did when Rudolph Ruzicka went there on a summer's day to make his drawings. In-cidentally, this engraving is the only one of the keepsakes that is horizontal in its composition, doubtless so that a broad view of the harbor is enhanced.

Castle Island, which commands the channel two and a half miles from Boston, was modestly fortified as early as 1634. By 1676 matters had improved to such an extent that Edward Randolph could speak of 'a castle of stone lately built, and in good repair, with four bastions, and mounted

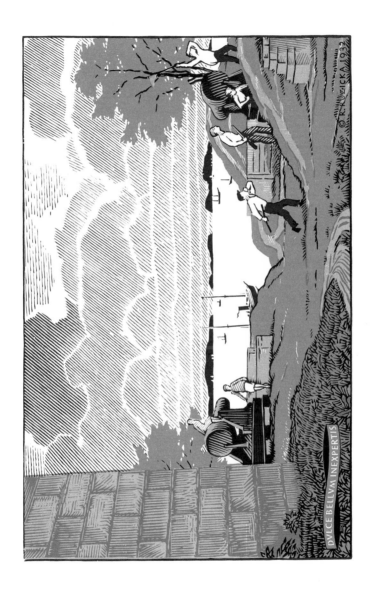

DVLCE BELLVM INEXPERTIS

© R.RUZICKA.1932

with 38 guns, 16 whole culverins, commodiously seated upon a rising ground sixty paces from the waterside, under which at high-water mark is a small stone battery of six guns.' When the news of the 'Glorious Revolution' reached Boston on 18 April 1689, the people rose in arms, captured the Castle, and dumped Sir Edmund Andros, the royal governor, into it, where he was imprisoned for eight months. In 1701 the locally improvised fortifications were replaced by a new Castle William, designed by Colonel William Wolfgang Römer, chief military engineer to their Royal Majesties in North America. For the next seventy-five years it remained the principal fortress of the town. When the British forces evacuated Boston on 17 March 1776, the garrison blew up the magazines, burned the barracks, and generally did their best to render the fort useless. General Washington promptly sent his second aide-de-camp, John Trumbull (only nineteen years old, but a Harvard A.B. of 1773), to take possession of the island and save what he could. Continental troops soon repaired the works under the command of Lieutenant Colonel Paul Revere. During the remainder of the Revolution, the chief military function of the fort was saluting arriving ships of the French fleet. At the end of the war, the island was used for the confinement of criminals thought to be too desperate to be risked in a county jail.

Massachusetts ceded Castle Island to the United States in 1798. When visited by President John Adams the following year, the name Fort Independence was bestowed upon the fortifications. During the War of 1812 the fort was garrisoned by details of Massachusetts militia. In the years following, a small garrison remained, which included Private Rochford who, as a *British* soldier, had served both under Wolfe at Quebec and at Bunker Hill: as an old man he found a snug harbor at Fort Independence, where he

composed songs for the amusement of his American comrades in arms. So matters rested until 1833, when the federal government began the construction of today's fort.

Fort Independence as we know it is the creation of the military engineer Sylvanus Thayer, born in Braintree in 1785, who after serving as Superintendent of the United States Military Academy at West Point from 1817 to 1833, spent the rest of his active career as engineer in charge of the fortifications of Boston Harbor and of harbor improvements on the New England coast. From local granite, Thayer constructed a five-sided fortress with massive casemates with guns commanding the channel and barracks looking out on an interior parade ground. Each of the five sides was protected by projecting bastions and flank defences. Inclined planes and stone stairways led from the parade ground to the ramparts.

When completed in 1851, Fort Independence was a model of harbor defence. Nevertheless, for want of enemy opposition, it was one of the most somnolent garrisons on the Atlantic coast. In 1879 it was evacuated by the Army, in order to concentrate forces at Fort Warren, further down the harbor. Thereafter it was defended only by a sergeant and a fort-keeper until the island passed to the care of the Boston Park Commissioners, who eventually made Castle Island freely available to children like me.

A View of University Hall,
Harvard University, Cambridge, 1924

After a dozen years, the keepsakes moved to Cambridge to depict the building by which during the War of 1812 Harvard College attempted to catch up with the latest elegances of Boston. When Charles Bulfinch undertook the construction of Stoughton Hall in 1804, he obeyed orders and modelled the new dormitory closely, in dimensions and style, upon its neighbor, Hollis Hall, which had been built in 1763. Consequently Stoughton, although built in the nineteenth century, presented no startling contrast to its eighteenth-century neighbors, Massachusetts, Harvard, and Hollis Halls and Holden Chapel. With University Hall, however, Bulfinch moved out of red brick into Chelmsford granite, which caused a conservative tutor to call the new building 'the white spectre.'

Although the building was to provide a 'Common Hall' for dining, it seemed prudent in the interest of public order to have individual rooms for the four classes, rather than a single great hall that would accommodate the entire undergraduate body. Bulfinch submitted three alternative designs late in 1812, of which the simplest was chosen. An elegant cupola was omitted because of expense, as well as two flights of stairs on the east façade. Because of the war, the beginning of construction was delayed until the summer of 1813; nevertheless the building was completed the following year at a cost of $65,000. Its material and its ele-

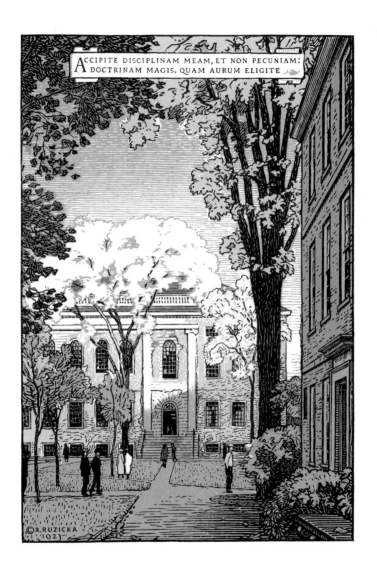

ACCIPITE DISCIPLINAM MEAM, ET NON PECUNIAM: DOCTRINAM MAGIS, QUAM AURUM ELIGITE

©R.RUZICKA
1923

gant proportions gave a new look to the Harvard Yard.

The first floor was given over to the four dining halls, which ran from front to back of the building. Samuel Eliot Morison observed that 'the large round oriels between the partitions on the ground floor were designed to give a certain unity to the Commencement dinner, which took up the entire ground floor; in the meantime, they offered tempting openings through which insults and bread could be hurled from one class to another.' Two stair corridors ran through the buildings, each of which gave access to two of the halls. Two kitchens were in the basement. On the second floor, above the two central halls, was a chapel, two stories in height, with six arched windows on both façades. At the ends of the building were classrooms on both the second and third floors. The stairs in both corridors were of granite, elegantly cantilevered. On the west façade a one-story colonnaded porch linked the two flights of granite steps that led into the building from the Yard. On either side of the two entrances Ionic pilasters rose the full height of the three floors. The basement walls and the areas around the entrances were rusticated: otherwise the walls were of severe ashlar. To the east of the hall was constructed a row of privies, screened by pine trees. Known as University Minor, these conveniences served the college until the 1870's, when plumbing was installed in the basements of all dormitories in the Yard.

University Hall has been through various metamorphoses in the past hundred and sixty years. The colonnaded porch was removed in 1842 to give increased light to the rooms that it formerly shaded. The Commons fell upon evil days; after being reduced to one room, they were abolished in 1849. Until Memorial Hall was completed a quarter of a century later, undergraduates nourished themselves as they pleased in Cambridge boarding houses without of-

ficial intervention. The second-floor chapel was abandoned in 1858, when Appleton Chapel was built on the site of the present Harvard Memorial Church. Although partitioned into smaller rooms for a time, the space was restored in 1896 as a meeting room for the Faculty of Arts and Sciences. On the walls of the Faculty Room hang portraits of presidents, early benefactors, and other especially eminent members of the University.

On the second floor at the south end of University Hall, Presidents Charles W. Eliot and A. Lawrence Lowell had their offices from 1869 to 1933. The Dean of Harvard College has long been based on the first floor in a repartitioned version of the two central Commons halls. When I was an undergraduate fifty years ago and Rudolph Ruzicka was engraving this view, University Hall accommodated most of the central administration of the University; that was a simpler world, unaware of the delights of computers and 'efficiency.' Since then the ground floor of Massachusetts Hall has been renovated for the more spacious accommodation of the President's office. Various offices, including those of the Dean of the Graduate School of Arts and Sciences, have moved elsewhere, but as the Dean of Harvard College remains in University 4, Mr. Updike's Latin reference to discipline is as pertinent as it was half a century ago.

XVIII

A View of Gore Hall and the Weeks
Memorial Bridge, Cambridge, 1928

The two words NISI DOMINUS invite the viewer to continue
with the first verse of Psalm 127—'Except the Lord build
the house, they labor in vain that build it'—and to apply it
to the many-faceted activities of Abbot Lawrence Lowell,
President of Harvard University from 1909 to 1933, which
culminated in the House Plan that was his great contribu-
tion to the undergraduate life of the college.

During the administration of his predecessor, Charles
W. Eliot (1869–1909), the professional schools had waxed
fat, while in the college the substitution of an elective sys-
tem for an older set curriculum had created a kind of aca-
demic 'free lunch counter' at which undergraduates might
follow their whims in the choice of courses, with more
thought of their future professional advancement than of
obtaining a truly liberal education. When Lowell became
President, he noted in his inaugural address, as Samuel
Eliot Morison has pointed out in *Three Centuries of Har-
vard*, that 'the College was in danger of being pinched out,
as in Germany, between secondary education (or "junior
colleges") and professional schools.' Furthermore, 'on the
social side, Mr. Lowell observed that at Oxford and Cam-
bridge there was a union of learning with the fine art of
living; and that, without there being any pretence of dem-
ocracy, the poorest student in a college was within reach of
the best that his college had to give.' Consequently Mr.

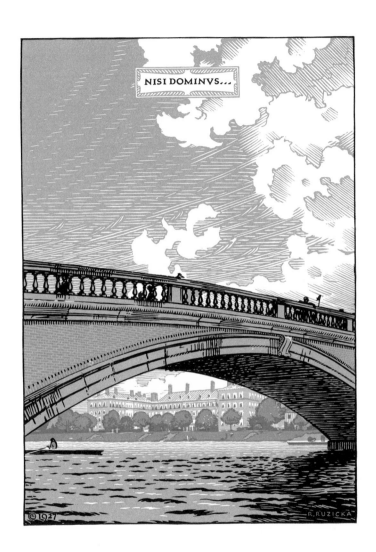

Lowell introduced in the college a program for 'concentration and distribution' in the choice of courses, the tutorial system, and the encouragement of students to seek the A.B. degree with honors in specified fields. To enhance a sense of collegiate life, he undertook the construction of a group of freshman halls, each with its own dining room, in which all members of the entering class would live.

For the first 275 years of its existence, Harvard resolutely turned its back on the Charles River. Through the nineteenth century, as the Yard became filled, new buildings were instead placed toward the north. Although a boat club had been founded in 1864, and a stadium built on the Boston bank of the Charles in 1904, the river was otherwise unimaginatively left to wharves, wood and coal yards, power plants, and modest wooden houses and tenements unconnected with the college. However, Edward Waldo Forbes, Director of the Fogg Art Museum, realizing early in this century that the University would eventually need the riverbank, with the aid of a few friends quietly purchased much of the land between Mount Auburn Street and the Charles so that it would be available when Harvard needed it. When the completion of the Charles River Dam in 1910 permanently raised the water to high-tide level, the Cambridge shore became so much more attractive that the Harvard Corporation gratefully took over the lands that Edward Forbes had so presciently assembled for them. Thus President Lowell had a delightful site for his new freshman halls, ready and waiting.

By the autumn of 1914 three of them were completed, from designs of Coolidge, Shepley, Bulfinch, and Abbot. Gore Hall, built by the subscription of alumni, and Standish Hall, given by Mrs. Russell Sage, were in the form of open quadrangles, facing the Charles. A third, Smith Hall, facing on Boylston Street around an enclosed court, was provided

by a carefully nurtured bequest from George Smith of the class of 1854. A fourth, McKinlock Hall, was given after World War I by the parents of George A. McKinlock, Jr., of the class of 1916, who was killed in France in 1918. By means of these halls, where all the freshmen lived and dined, President Lowell considerably strengthened the homogeneity of the college, as well as creating an attractive river front on the Cambridge shore. He improved the view from Gore and Standish Halls in the next decade when, through a great gift from George F. Baker, he built a whole complex of buildings on the opposite Boston shore for the Graduate School of Business Administration.

The graceful footbridge shown in this engraving, which linked the new Business School to the rest of the University, bears the name of Senator John Wingate Weeks of Newton, President Harding's Secretary of War, who died on 12 July 1926. As it has never been heavily travelled by pedestrians, one may suspect that some of its purpose was to get heating pipes across the river to the new Business School, and that it was more readily accepted by the city governments of Cambridge and Boston as a memorial to an esteemed public figure than it would have been as a logistic convenience. Be that as it may, the Weeks Memorial Bridge is a highly attractive addition to the Charles River.

XIX

A View of Lowell House,
Harvard University, 1932

The freshman halls were only the first step in President Lowell's plan to enhance the social and intellectual homogeneity of Harvard College. Freshmen lived together there by the river for one year. Seniors tended to congregate in the old dormitories in the Yard, but, from shortage of other college housing, sophomores and juniors were mostly scattered on the town, eating around as they chose. As Memorial Hall Commons, which had been operated at a loss for some years, closed in 1924, there was no provision for victualing upper-classmen under college auspices.

As early as 1907, two years before he became President of Harvard, Lawrence Lowell in an address at Yale had considered the social implications of such *laissez faire* fragmentation. 'The obvious solution,' he said, 'is to break the undergraduate body into groups like the English colleges, large enough to give each man a chance to associate closely with a considerable number of his fellows, and not so large as to cause a division into exclusive cliques.' For twenty years he planned such a reorganization to such purpose that when funds came in sight no time was lost. In the autumn of 1928, Edward S. Harkness of the Yale class of 1897 offered President Lowell three million dollars to build and endow an 'Honor College' for members of the three upper classes, with resident tutors and a master. Mr. Harkness had earlier proposed such a plan to Yale; discouraged by

VICILATE ERGO: NESCITIS·ENIM, QUANDO DOMINUS DOMUS VENIAT.

R. Ruzicka
©1931

backing and filling at his own university, he tried Harvard. Lawrence Lowell not only accepted on the spot, but set forth his aspirations so persuasively that in a few weeks Mr. Harkness raised his gift to ten millions in order to provide seven houses that would house the bulk of the sophomore, junior, and senior classes!

Three houses were built on or near the Charles River: four others were created out of the freshman halls and other existing dormitories. Freshmen were moved to the old dormitories in the Yard and the Harvard Union was fitted up for their meals and recreation. Within three years from the day Mr. Harkness walked into President Lowell's office for the first time, all seven houses were in full operation, with dining halls, common rooms, libraries, and resident tutors and masters! Dunster and Lowell Houses, designed from the ground up, opened in the fall of 1930. Eliot House, also entirely new, took longer to complete, as to clear its site a power station at the corner of Boylston Street and Memorial Drive had to be demolished. With certain additions and modifications the freshman halls were converted into Leverett, Winthrop, and Kirkland Houses, while Adams House was created out of older 'Gold Coast' dormitories in Mount Auburn Street. Two years before he retired in 1933, Lawrence Lowell had subdivided Harvard College into seven parts. With the growth of the college since his time, two additional houses—Quincy and Mather —have been built. Having transformed Harvard by his gift, Edward S. Harkness then forgivingly returned to his alma mater and helped turn Yale into a group of similar colleges.

In designing Lowell House, Charles A. Coolidge, whose firm had earlier built the freshman halls, created two large interior courts which compensated for the lack of the river views enjoyed by Dunster and Eliot. The most conspic-

uous feature of the house is a square entrance tower, containing a peal of great Russian bells, surmounted by an octagonal cupola with a blue roof. Our engraving shows the tower as seen from the smaller court. Although the scale is vast, certain details of Lowell House recall the eighteenth-century red brick structures of the Yard. In Lawrence Lowell's time it was not considered imperative that new Harvard buildings should ignore or clash with their earlier neighbors. When I was Allston Burr Senior Tutor of Lowell House from 1952 to 1956, I greatly enjoyed the sight of this tower from my office window, as I delighted in the view of the Park Street steeple from my Athenaeum desk. But the open space below offered the quick in Cambridge and the dead in Boston.

The use of Mark 13:35—'Watch ye therefore: for ye know not when the master of the house cometh'—involves a very Updikean pun, for in the academic year 1929–1930 the Watch and Ward Society in Boston made itself unpopular with undergraduates by harassing booksellers. As Julian Lowell Coolidge, Professor of Mathematics and Master-designate of Lowell House, was an officer of that society, students began to grumble about the house plan. Professor Coolidge sensibly cut his ties with the Watch and Ward, and until his retirement in 1940 did as much as any single man besides his cousin Lawrence Lowell to make the plan a successful part of Harvard life.

XX

View of the First Church, Lancaster, Massachusetts, 1917

This sixth keepsake was the first in which Mr. Updike proposed a subject beyond the city limits of Boston. Although Boston scenes were by no means exhausted, the summer of 1916, when Mr. Ruzicka would be at work on the New Year's Greetings for 1917, marked the hundredth anniversary of the Lancaster church. Psalm 84:1—'O how amiable are thy dwellings, thou Lord of Hosts' in the Book of Common Prayer translation—applied aptly to this building designed by Charles Bulfinch. Moreover, the minister of Lancaster was the most devoted student of that architect's work in his generation: the Reverend Charles A. Place's *Charles Bulfinch Architect & Citizen* was published by Houghton Mifflin Company in 1925. Of the eight churches built by Bulfinch, only this and St. Stephen's in Hanover Street have been preserved.

The Lancaster meeting house was built in 1816 during the pastorate of the Reverend Nathaniel Thayer, a Harvard graduate of 1789 who enjoyed sufficient repute to receive from the college in 1817 the honorary degree of S.T.D. The cornerstone having been laid on 9 July, the building was completed in the course of 151 working days; in country New England in 1816 there were no interruptions from strikes and jurisdictional disputes to delay Thomas Hearsey, the master builder, in carrying out his task. The church

was dedicated on New Year's day, 1817; the cost of a little

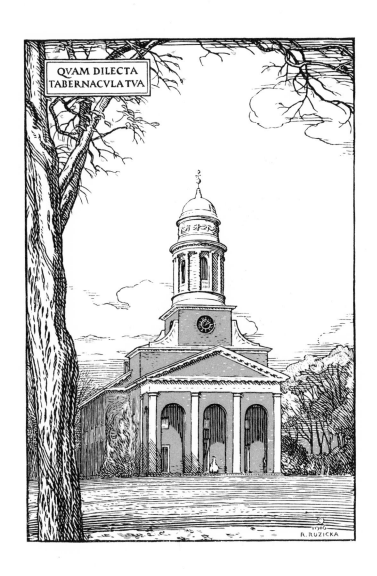

under twenty thousand dollars was assessed upon the owners of the pews. Mr. Place noted with pride that it 'was reared almost wholly by artisans of Lancaster—a noble memorial to their skill and integrity—of Lancaster brick in Flemish bond, Lancaster timber, and the celebrated Bolton lime.' What better combination could there be than a Bulfinch design, promptly executed in local materials, by Lancaster workmen who were constructing their own meeting house?

When it was still new the church was described thus by Joseph Willard in his *Topographical and Historical Sketches of the Town of Lancaster*, published at Worcester in 1826: 'The body of the building is 74 by 66 feet, with a porch, portico, tower and cupola. The portico is 48 by 17 feet, of square brick columns, arched with pilasters, entablature, and pediment of the Doric order; the vestibule, or porch, is 48 by 19 feet and contains the gallery stairs; the tower is 21 feet square; the cupola is circular, and of singular beauty; it is surrounded with a colonnade of 12 fluted pillars, with entablature, and cornice, of the Ionic order; above which is an Attic encircled with a festoon drapery, the whole surmounted by a dome, balls and vane. The height from the ground is about 120 feet. Inside, the front of the gallery is of ballustrade work, and is supported by ten fluted pillars of the Doric order, and has a clock in front, presented by a gentleman of the society. The pulpit rests on eight fluted columns, and four pilasters of the Ionic order; the upper section is supported by six Corinthian columns also fluted, and is lighted by a circular headed window, ornamented with double pilasters fluted; entablature and cornice of the Corinthian order; this is decorated with a curtain and drapery from a Parisian model, which, with the materials, were presented by a friend; they are of rich green figured satin.'

The interior of the Lancaster church has remained un-

spoiled, thanks to the taste and historical knowledge of its pastors. An ill-considered proposal in 1869 to insert a floor at the gallery level across the entire interior, so as to create a lower vestry and an upper church, was successfully resisted by the Reverend George M. Bartol. The addition in 1881 of the Thayer Memorial Chapel, connecting with the church, necessitated only the closing of the arched window above the pulpit and the cutting of two doors: otherwise the interior has changed little. Charles A. Place long safeguarded the integrity of the church, while the Reverend Frederick Lewis Weis, who was its minister more recently, was an assiduous antiquary, whose publications added much to our knowledge of the clergy of the various colonies of British North America.

The cupola of the Lancaster church was the one Bulfinch had designed for University Hall at Harvard which for reasons of economy was not built. Thayer Hall, next to University, was given to Harvard College in 1869–1870 by Nathaniel Thayer, Jr. (1808–1883), a son of the Reverend Nathaniel Thayer who built this church.

A View at Camp Devens,
near Ayer, Massachusetts, 1918

This solitary excursion into the twentieth century and un-
distinguished architecture marks the transition from peace
to war. In 1916 the keepsakes celebrated the centenary of
Charles Bulfinch's idyllic church at Lancaster. The en-
trance of the United States in the war against Germany on
6 April 1917 made the nearby town of Ayer familiar to
thousands of Americans who had never heard of it before.
Hitherto this Middlesex County town, in 1871 carved out
of the colonial farming communities of Groton and Shirley,
had been chiefly known as a country railroad junction. This
accessibility by rail, combined with a good deal of open
country of varied terrain, made it the ideal site for the cre-
ation of a vast Army camp where troops were trained be-
fore being sent overseas.

The Latin text this time came not from the Vulgate but
from the seal of the Commonwealth of Massachusetts: 'By
the sword we seek peace, but peace only under liberty.' The
scene shows khaki-clad soldiers being drilled, against a
background of hastily constructed wooden barracks con-
nected by overhead heating pipes. In the forefround a body
of recruits, still in civilian clothes, shuffle toward an un-
known destination, while a few ladies watch the drill. The
scene corresponds exactly to my recollections of visits to
Camp Devens at the age of twelve. I remember vividly the
smell of unseasoned wood in the freshly constructed build-

ENSE PETIT PLACIDAM
SVB LIBERTATE QVIETEM

©·R·RUZICKA·1917

ings and the violent contrast between their overheated interiors and the icy cold outside. It was all new, vast, and dreary. It seemed to go on forever. And it suggested a less romantic view of war than the granite walls of Fort Independence.

On 12 December 1917 Edith Lawrence (Mrs. Harold Jefferson) Coolidge, a Boston lady of great energy, charm, and curiosity, whose family originally hailed from Groton, motored to Ayer over icy roads to see the great cantonment. She recorded in her unpublished diary: 'We drove in through the gate, with sentries presenting arms, and went first to the new Young Women's Christian Association "Hut". The roads were wide and splendid like a park, and contrary to my expectations, the grounds were hilly, with scrub pine and gray birches all about. The endless, long tar paper and plank buildings, each large group chaperoned by a pair of gigantic galvanized chimneys of the heating plant, composed a more cheerful picture than I had thought possible. Having known this very piece of country on the Shirley Road in my youthful Groton days, I seemed to be living in a queer dream, to see this framework city of thirty thousand inhabitants, sprung up almost over night.'

Mrs. Coolidge then went on to visit the Hostess Hut—'practical but not attractive, all one enormous room, with a chimney and fireplace in the middle, between the restaurant and sitting room, with no privacy possible'—before motoring half a mile to see Lieutenant George Amory's quarters 'in a neat, very steamheated wooden building' given over to the 301st Infantry, and the Base Hospital, 'where we found the steam heat almost unbearable.' 'This great system, about which we had heard such a lot of croaking, is almost too much of a success, and the tremendous amount of overheated, unprotected pipes have not had a chance to freeze in the zero weather.'

Although created with great speed during the First World War, Devens has remained in continuous use. Now as Fort Devens, it is the principal Army headquarters in the region and an installation of solid consequence. Improvised plank and tar paper buildings have given way to permanent brick, while with the passage of more than half a century it has settled into the landscape as plantings have grown up. Only the name it honors remains from 1917: Major General Charles Devens (1820–1891), born in Charlestown, who attended Harvard, practiced law in Worcester, and won military distinctions in the Civil War. He was appointed to the bench of the Massachusetts Superior Court in 1867. From 1873 until his death he was a justice of the Massachusetts Supreme Judicial Court, save for an interval as Attorney General in the cabinet of President Hayes. The Commonwealth of Massachusetts in 1894 appropriated funds for a bronze statue of him in uniform by Olin L. Warner that was placed in the State House grounds near Bowdoin Street. The creation of a new parking lot in 1950 caused the banishment of General Devens to the Charles River Esplanade at the foot of Beacon Hill.

A View of Walden Pond,
near Concord, Massachusetts, 1927

On Christmas Eve 1841—a festival that he did not deign to notice—the twenty-four-year-old Henry David Thoreau entered in his journal: 'I want to go soon and live away by the pond, where I shall hear only the wind whispering among the reeds. It will be success if I shall have left my-self behind. But my friends ask what will I do when I get there? Will it not be employment enough to watch the progress of the seasons?' In the four years since his gradua-tion from Harvard College, Thoreau had taught school a bit, helped his father make lead pencils, and spent thirteen memorable days paddling down the Concord River and up the Merrimack as far as the New Hampshire Concord, in the company of his brother John. Three and a half years passed, however, before the wish 'to live away by the pond' was carried out.

Instead he lived in the Concord, Massachusetts, home of Ralph Waldo Emerson, where he became friendly with the Transcendental Club, wrote poems and essays, and lent a hand with gardening and fence-mending. For a year he was a tutor in the family of Emerson's brother William, on Staten Island; this was the longest period he ever spent away from his native Concord. On returning early in 1844, the idea of the pond revived. His friend Stearns Wheeler had lived in a hut by Sandy Pond for a time in 1841–1842, where Thoreau had stayed with him. On 5 March 1845 an-

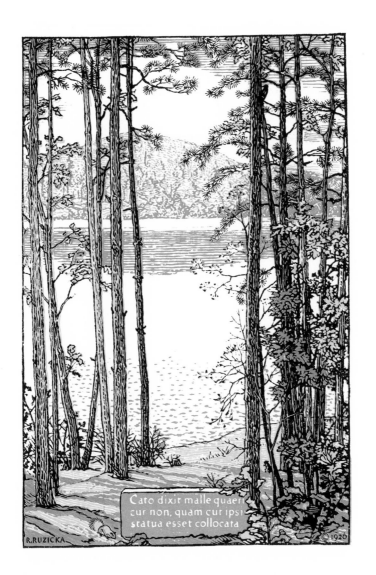

Cato dixit malle quaeri
cur non, quam cur ipsi
statua esset collocata

R.RUZICKA. ©1926

other friend, Ellery Channing, wrote: 'I see nothing for you in this earth but that field which I once christened "Briars"; go out upon that, build yourself a hut, and there begin the process of devouring yourself alive.' So, as Thoreau wrote in *Walden*: 'Near the end of March, 1845, I borrowed an axe and went down to the woods by Walden Pond, nearest to where I intended to build my house, and began to cut down some tall arrowy white pines, still in their youth, for timber.' For some days he cut and hewed timber for studs and rafters. For boards, he bought for $4.25 the shanty of James Collins, an Irishman who worked on the Fitchburg Railroad. 'I took down this dwelling the following morning, drawing the nails, and removed it to the pond by small cartloads, spreading the boards on the grass there to bleach and warp back again in the sun.' At the beginning of May he set up the frame, and moved in on the Fourth of July. Before winter he built a chimney, and shingled the sides, thus achieving, for the reasonable cost of $28.12½ (excluding his own labor), 'a tight shingled and plastered house, ten feet wide by fifteen long, and eight-feet posts, with a garret and a closet, a large window on each side, two trap doors, one door at the end, and a brick fireplace opposite.'

In that house Thoreau pursued, from 4 July 1845 to 6 September 1847, what David McCord calls 'his compost-graduate studies at Walden.' But let no one think that he had retreated to the wilderness to recreate the solitary austerities of early hermits in the Egyptian desert. The land on which he built on the northwest shore of Walden Pond was owned by his friend Emerson; it was, moreover, only a mile and a half south of the village of Concord. 'The Fitchburg Railroad touches the pond about a hundred rods south of where I dwell. I usually go to the village along its causeway, and am, as it were, related to society by this

link. The men on the freight trains, who go over the whole length of the road, bow to me as an old acquaintance, they pass me so often.' 'Every day or two I strolled to the village to hear some of the gossip which is incessantly going on there, circulating from mouth to mouth, or from newspaper to newspaper, and which, taken in homeopathic doses, was really as refreshing in its way as the rustle of leaves and the peeping of frogs. As I walked in the woods to see birds and squirrels, so I walked in the village to see men and boys.' And he often went to dinner with the Emersons, Alcotts, and Hosmers, just as he always had.

Thoreau left Walden Pond for good after two years, two months, and two days residence there. He returned to the Emerson house in Concord to keep the family company while Ralph Waldo Emerson was lecturing in England. His 'compost-graduate studies' had proved that he could support himself at Walden by working at the most six weeks a year; he also achieved the first drafts of the two books published in his lifetime. Since Ticknor & Fields first brought out *Walden or Life in the Woods* in 1854, the book has gone through countless editions; to me the most beautiful is that published in 1930 by the Lakeside Press in Chicago, designed and illustrated with thirty-five drawings by Rudolph Ruzicka. Alas, this superb example of the graphic arts, having been issued in an edition of only one thousand copies, is too seldom to be seen.

A View of Gore Place,
Waltham, Massachusetts, 1939

Coming from Walden to this noble mansion, one realizes
the diversity of tastes among Harvard alumni, few of whom
had less in common than the Transcendentalist Henry Da-
vid Thoreau (A.B. 1837) and the Federalist Honorable
Christopher Gore (A.B. 1776). David McCord, when
writing an essay in 1957 to raise money for the Harvard
Fund, chose his title from the last four words of Thoreau's
observation, 'Some circumstantial evidence is very strong,
as when you find a trout in the milk.' There he observed
that for all 'the light and luster he has shed upon the world
beyond his Harvard, [Thoreau] was far from being, in fact
or potentially, the tractable alumnus. One cannot imagine
him as an Overseer. ("It is hard to have a Southern over-
seer; it is worse to have a Northern one.") . . . Or a con-
tributor to the Harvard Fund. ("Others have been curious
to learn what portion of my income I devoted to charitable
purposes.") Or a marcher in the Commencement proces-
sion. ("If a man does not keep pace with his companions,
perhaps it is because he hears a different drummer.") Or
even a member of the Committee on the Happy Observance
of Commencement. ("I hear an irresistible voice which in-
vites me away from all that.")'

Christopher Gore was of a different stripe. He became a
lawyer-politician at a moment when the confusions of the
Revolution gave opportunity for ambitious young men to

move ahead. He married well. Believing that property must be guarded against radical attacks, he threw in his lot with the Federalists. By successful speculation in public funds, and similar ventures, he possessed a fortune at thirty-four. In 1789 President Washington named Gore District Attorney for Massachusetts. The years 1796 to 1804 he spent in London on a diplomatic mission. He was Governor of Massachusetts in 1809, and a United States Senator from 1813 until 1816, when he resigned because of failing health. Overseer of Harvard from 1810 to 1815, Gore was a member of the Corporation from 1812 to 1821. On his death in 1827 he bequeathed $100,000 to Harvard, a gift exceeding 'the munificence of any other benefactor.' A new Gothic library, named Gore Hall, was built by the college in 1838–1841; when this structure was demolished in 1912 to make way for the Widener Library, Gore's name was soon transferred to one of President Lowell's new freshman halls, today part of Winthrop House. David McCord would have given Christopher Gore good marks as 'a tractable alumnus.'

The Honorable Christopher Gore's residences suited their occupant as appropriately as the Walden cabin did Thoreau. In Boston he moved with the fashion from Bowdoin Square to Park Street, and in 1793 he built a house on a three-hundred-acre farm in Waltham, ten miles from Boston, which the Reverend William Bentley characterized as a 'splendid seat.' As this country house was damaged by fire in 1799 during Gore's absence in Europe, the Gore Place of this engraving was begun soon after his return. During their eight years abroad Gore and his wife collected ideas from seats of the British gentry and nobility. In England they were attracted by the work of Sir John Soane; in Paris they submitted a sketch of their proposed house to the architect Jacques-Guillaume Legrand.

Ground was broken at Waltham in March 1805 for a five-part structure with a dominant central block, and lower wings leading to terminal pavilions. Although the proportions of the elements are different, such an organization of the plan is not unlike that of Tudor Place in Georgetown, D.C., built in the same decade for Thomas Peter by Dr. William Thornton. Both houses would have made handsome gentlemen's seats in Regency England. Gore Place was built in New England red brick. Both indoors and out it was severely free of ornament. Its impressiveness depended upon its size, symmetry, proportion, excellence of construction, and skillful fenestration. The garden façade is dominated by the curve of the central oval dining room, while this shape is echoed in the elliptical inner wall of the adjacent state hall on the other side of the house. The cost of construction was $23,608.14, as opposed to $28.12½ at Walden.

Gore Place was indeed DULCE DOMUM. Although its builder died in 1827, it remained a handsome country house through the rest of the nineteenth century. The last private occupants, the Misses Harriet Sarah and Maria Sophia Walker, bequeathed it in 1902 to the Episcopal Diocese of Massachusetts, hoping that the land might become the site of a new cathedral, or that at least Gore Place might become the bishop's residence. As such a proposal was too much in the Anglican tradition of pre-Trollope days for Bishop Lawrence, Gore Place instead of becoming a bishop's palace fell into ignoble uses, from which it was eventually rescued by the Gore Place Society, a private organization that devotedly restored it and preserves it as an architectural monument.

XXIV

A View of the House of the Seven Gables, Salem, Massachusetts, 1926

As my earliest school rooms were decorated with likenesses of New England authors—Longfellow, Lowell, Emerson, Hawthorne, Holmes—whose works were readily accessible through the enterprise of Houghton Mifflin Company, these writers were household gods in my childhood. In Cambridge I looked through fences at Craigie House and Elmwood, where Longfellow and Lowell had lived thirty years or less ago. That then seemed the remote past, for anything preceding one's own birth verges on eternity. I now realize that it was a far shorter time than has elapsed since my mother, in a Model T Ford, improved my mind by literary pilgrimages. We went, of course, to Concord, but Salem was one of the particular excitements, for there was Nathaniel Hawthorne's *The House of the Seven Gables*, 'itself in person,' as an Irishman might put it. Regardless of the fact that Hawthorne had written a novel in which he had taken full advantage of the artist's prerogative to select, blend, and transmute from reality what suited his purpose, the Turner-Ingersoll house at 54 Turner Street is so firmly fixed in the popular imagination as the site that Michel de Montaigne's identification of himself with his book (and vice versa) applies appropriately to this engraving.

After graduation from Bowdoin in 1825, Nathaniel Hawthorne returned to his native Salem, where he devoted a

94

© R. RUZICKA · 1925

Tout le monde me recognoist en mon livre, & mon livre en moy

dozen years to establishing himself as a man of letters. The
need of money led him to seek public employment. Through
the help of his Bowdoin friend Franklin Pierce, he obtained
in 1839 a post as weigher and gager in the Boston Custom-
House. A change of party two years later having caused
him to resign his post, Hawthorne then tried Transcenden-
tal community life at Brook Farm in West Roxbury, Mas-
sachusetts, until 1842, when he married Sophia Amelia
Peabody of Salem. After three idyllic years in the Old
Manse at Concord, want of funds drove the couple back to
Salem, where Hawthorne obtained appointment as Sur-
veyor of the Port. This post too he lost with a change in
parties in 1849. Although his years in the brick Salem Cus-
tom-House at the head of Derby Wharf were as uncongen-
ial as those of his earlier duty in the granite Doric temple in
Boston, he stored up during them impressions that flow-
ered in the novels that he wrote when he involuntarily re-
turned to private life.

By Hawthorne's time, the Salem Custom-House, once
crowded with imports from distant voyages, was becoming
somnolent, for the great days of the port's foreign trade
were over. As the harbor was too shallow to receive large
vessels, the more enterprising Salem merchants sent their
ships, and often removed themselves, to Boston or New
York. So Salem became introspective, backward-looking,
and sorry for itself, as Hawthorne was for himself. *The
House of the Seven Gables*, Hawthorne's farewell to his na-
tive place, was written rapidly in a cottage at Tanglewood
in the Berkshires between August 1850 and late January
1851. It was drawn from his knowledge of many houses
and households. There is, however, a tradition that his
cousin Susan Ingersoll once took him to the attic of the
house in Turner Street to prove that it had once had seven
gables, and that he murmured as he came down the narrow

stairs, 'House of the Seven Gables—that sounds well.'

In a brilliant chapter of *The Image, Or What Happened to the American Dream*, Daniel J. Boorstin points out how 'in order to satisfy the exaggerated expectations of tour agents and tourists, people everywhere obligingly become dishonest mimics of themselves.' An extreme case of nature imitating art, or man biting dog, recently occurred in New Bedford, Massachusetts, when the original pulpit of the Seaman's Bethel on Johnny Cake Hill was replaced by a modern fake-prow of a ship, so as not to disappoint readers of Herman Melville, who had described a sermon there in figurative terms. The Turner-Ingersoll house in Salem was bought in 1909 by Miss Caroline B. Emmerton who made it the center of a neighborhood settlement in what was then a sordid slum. This was an admirable method of preserving a seventeenth-century house by adapting it to a good contemporary use. In the course of the restoration, however, the requisite number of gables, and other details from Hawthorne's imagination, were supplied until '*tout le monde recognoist mon livre en moy.*' As the tourist trade has waxed and settlement house activities waned, by the odd process of history imitating literature, it has become fixed in everyone's mind as *The House of the Seven Gables*. In spite of that, it is a charming spot.

XXV

A View of the Market House at
Salem, Massachusetts, 1941

The American sport of knocking down handsome examples
of architecture to replace them with workaday buildings is
not a twentieth-century invention. It was practiced far too
often in the nineteenth century with some of Charles Bul-
finch's finest creations. As an example, the Salem Market
House stands upon a site that was occupied for only sixteen
years by the mansion of the Salem merchant Elias Hasket
Derby.

Like Harrison Gray Otis in Boston only a few years lat-
er, Derby frequently enlarged his notions of a suitable
residence. In 1780, having outgrown a small brick house
near Derby Wharf, he commissioned Samuel McIntire to
design him a larger three-story one at 96 Derby Street. But
in 1782 he bought the Pickman house at 70 Washington
Street and moved there, remodelling it handsomely in
1786. Nevertheless, at his wife's instigation, he began in
1795 to plan for still another residence. Although the 'Der-
by Mansion,' as it was always called, was built by Mc-
Intire, the original design was by Bulfinch, who modelled
the elegant Palladian façade upon General Wade's house in
London, a work of Lord Burlington's that had already been
reproduced in the Provost's house in Dublin. On the site in
Essex Street stood the substantial house of Samuel Browne,
who had died in 1731; its demolition caused the Reverend
William Bentley to enter in his diary for 9 May 1795: 'The

98

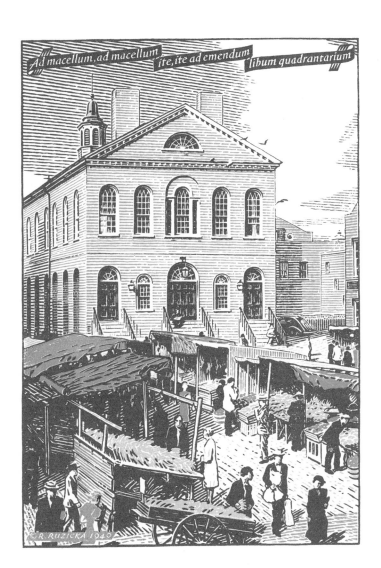

Ad macellum, ad macellum ite, ite ad emendum libum quadrantarium

©R. RUZICKA 1940

taking down of the large house of Col. Browne by Mr. Derby is a strange event in this town, it being the first sacrifice of a decent building ever made in the Town to Convenience, or pleasure.' The Derby mansion had scarcely been completed and occupied in 1799 when Mrs. Derby died on 19 April. When her husband followed her on 8 September, the house was taken over by the eldest son, Elias Hasket Derby, Jr., who lived there for a decade. But in 1811 the younger Derby moved to the country, putting up the mansion for sale. As no purchaser appeared, the family conveyed a portion of the site to the town to be used as a public market, and on 20 November 1815 demolition began. Dr. Bentley noted: 'It was the best finished, most elegant, & best constructed House I ever saw.'

The area given for the market, running downhill to Front Street, which was then on the water, was named Derby Square in honor of the donors. The brick house that was built there in 1816 at a cost of twelve thousand dollars followed the principle of Faneuil Hall in Boston, with market stalls on the first floor and a town hall on the second. Dr. Bentley, remembering the glories of the Derby mansion, observed on 23 November 1816 that 'the Market house is without style' and that 'the Butchers propose the exclusive possession of the whole floor of the Market house, so that everything else must be accommodated under the sheds.' When it opened on 25 November he noted: 'The Stalls were abundantly supplied & almost every person purchased something. Mr. Sawyer says he sold from his stall 9 quarters of beef.' Although beef has long since vanished from the first floor of the Market House, the carts of produce and provision dealers still filled Derby Square on Saturdays in 1940, when this engraving was made.

The Town Hall, on the second floor of the Market House, was used for town meetings until the incorporation of Sa-

lem as a city in 1836. Since then, municipal government has resided in the granite City Hall in Washington Street, built in 1837 from surplus revenue of the United States Treasury (!), distributed to the states, and by them to the cities and towns. The Town Hall was first opened to the citizenry on 8 July 1817 when President James Monroe visited Salem. Dr. Bentley noted that the President passed there to hear an address before going to the Salem Coffee House for a collation, where 'after toasts from the President, Governor, and many of the company, the President went again to the Town Hall, where he was received by a most brilliant assembly of Ladies, & by our best citizens. . . . At the hall he had all the condescention which is most winning in polite circles. . . . The Hall was festooned very handsomely & illuminated with pleasing effect.' In recent years the region of the Market House had become delapidated. The restoration of adjacent buildings in Front Street during 1974 by the Salem Redevelopment Authority has done much to improve its setting.

I cannot be sure where Mr. Updike found the Latin version of 'To market, to market,' but I suspect that Professor Edward Kennard Rand of Harvard may have supplied it.

XXVI

A View of the Summer House at
Glen Magna Farms,
Danvers, Massachusetts, 1940

Although Elias Hasket Derby's Salem mansion was de-
molished sixteen years after his death in 1799, this en-
chanting summer house that Samuel McIntire built a few
years earlier for the garden of Derby's farm has survived.
It is a tantalizing reminder of what the Salem architect and
woodcarver could achieve when working for the principal
merchant of the town. On the farm that Derby bought in
1776 in South Danvers, now Peabody, Massachusetts, he
developed a famous garden, adorned by the amenities of
architecture and sculpture. Eliza Southgate, who visited
the farm in 1802, considered the gardens 'superior to any I
have ever seen of the kind,' and thus described the subject
of this engraving: 'The summer house in the center has an
arch thro' it, with three doors on each side which open into
little apartments and one of them opens into a staircase by
which you ascend into a square room, the whole size of the
building; it has a fine airy appearance and commands a view
of the whole garden. . . . The room is ornamented with
some Chinese figures.' The roof of the summer house was
ornamented by urns and wooden statues over the gables of
a Gardener and Shepherdess, carved by John and Simeon
Skillin of Boston.

102 The Latin text equating gardens and peace is belied by

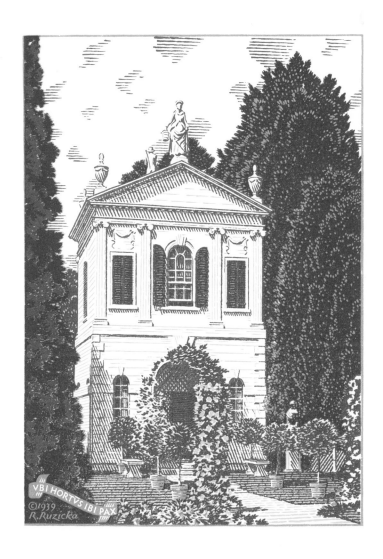

UBI HORTUS IBI PAX

©1939
R. Ruzicka

the history of this summer house. After passing through various hands, the Derby farm was sold out of the family and fell upon evil days. The gardens decayed; the farmland was sold. Within my memory the house lingered, surrounded by suburban nastiness, as a ghostly reminder; I was relieved when, very recently, someone tore it down. Fortunately the summer house was rescued in 1901 by Mrs. William Crowninshield Endicott (1833–1927), who removed it to Glen Magna Farms in Danvers. Her grandfather, Captain Joseph Peabody, East India merchant, had bought this farm in 1814 to provide a safe refuge for his family and goods against a British bombardment of Salem. Here too, eighty-seven years later, the summer house found a safe refuge.

Its savior's son, the younger William Crowninshield Endicott (1860–1936), transformed the farm into one of the handsomest country places in Massachusetts. He was an exuberant, explosive, generous, and childless man, who, with the encouragement of his mother and the acquiescence of a devoted wife, gathered about him all the vestiges of the past that his ample means and abounding energies could encompass. He became, in a sense, the embodiment of that past, for by the time of his death he was President of the Massachusetts Historical Society, of the Society for the Preservation of New England Antiquities, of the Massachusetts Horticultural Society, of the Essex Institute, of the Isabella Stewart Gardner Museum, Vice-President of the Peabody Museum of Salem, Treasurer of the Museum of Fine Arts, and heaven knows what else. The family farm at Danvers—enlarged through the architectural skill of his friend Herbert Browne—acquired more bay trees, French silver-gilt ornaments, Aubusson rugs, Chinese export porcelain, and garden statuary than Captain Joseph Peabody ever could have imagined. Through Mr. Endicott's

enthusiastic efforts the Derby summer house found itself in a setting handsomer than it had originally enjoyed.

From the Endicott house one passed through a formal garden enclosed by buckthorn hedges, laid out for Joseph Peabody, to a more romantic area, designed in 1897–1898 during summer visits from England by the Right Honourable Joseph Chamberlain, William Endicott's brother-in-law. There in 1901 the summer house was happily placed. Behind it a walled rose garden was created in 1904 from the designs of Herbert Browne; this one entered through the archway. The upper room of the summer house was enchantingly furnished with objects from the China trade: in the twilight, with candles in hurricane shades, it suggested a prim version of an eighteenth-century Venetian casino, transported by some magic carpet to Essex County.

On the death of the younger Mrs. Endicott in 1958, Glen Magna Farms were sold, for no member of the family could contemplate keeping the great place up. Mrs. Endicott, however, bequeathed the summer house to the Danvers Historical Society. For a time there were suggestions of moving it to Salem or to Gore Place, but residents of Danvers were unwilling for it to leave their town. Thus it is still happily on the site it has occupied since 1901, for the Danvers neighbors, by stalwart effort, have been able to protect the farm from subdivision, and maintain it as a municipal amenity of open space, although in less sumptuous form than in the days of the Endicotts.

A View of the Adams Mansion,
Quincy, Massachusetts, 1929

The opening words of Ecclesiasticus 44:1—'Let us now praise famous men'— carry us on to verses 3 and 4, which characterize the residents of this simple New England house: 'Such as did bear rule in their kingdoms, men renowned for their power, giving counsel by their understanding; leaders of the people by their counsels, and by their knowledge of learning meet for the people, wise and eloquent in their instructions.'

The house was built in 1731 as the country residence of Major Leonard Vassall, a West India planter who came to Boston in 1723. It was bought from Vassall heirs in 1787 by John Adams, while still in London as Minister to the Court of St. James's, in expectation of returning to rural retirement in Massachusetts. He got back in June 1788, but had only about nine months in which to settle into his new residence, unpack his books, and look over his fields. From 1789 to 1801 two terms as Vice President for General Washington and one as President of the United States kept him away from his house, save in summers. But from the end of his presidency until his death on 4 July 1826, he occupied this house winter and summer. With him until her death in 1818 lived Abigail, 'his beloved and only wife,' as she is described on their memorial tablet in the Stone Temple at Quincy.

The 'Old House,' as it has always been called in the fam-

LAVDEMVS VIROS GLORIOSOS—

© R.Ruzicka 1928

ily, passed on John Adams's death to his son John Quincy, then midway in his term as sixth President of the United States. On leaving the White House, John Quincy Adams returned home, but unlike his father on retirement he had another career ahead. Elected to the House of Representatives in 1831, he served the Plymouth District in eight successive Congresses; stricken at his desk in the House on 21 February 1848, he died in Washington two days later. Although the Old House was occupied by four generations of Adamses, it was only President John who lived in it the year round. Charles Francis Adams, in the third generation, had a house in Boston, but summered in Quincy, as did his sons, Henry and Brooks Adams. With the death of Brooks Adams, on 13 February 1927, one hundred and forty years of family occupancy came to an end. However, the rest of the family formed a corporation, the Adams Memorial Society, to maintain it as a memorial, like Mount Vernon and Monticello, with the desire of keeping as far as possible the personal accumulations of four generations untouched, as if the family were still there. Since 1946, when the Adams Memorial Society transferred the Old House and its contents to the federal government, it has been administered by the National Park Service as the Adams National Historic Site. Because the Park Service appointed as its first Superintendent Mrs. Wilhelmina S. Harris, who had been secretary to Mr. and Mrs. Brooks Adams in their last years, a sense of family continuity has marked the Site's administration.

Today the rooms of the Old House display cheek by jowl such dissimilarities as graceful Louis XV chairs, bought by John Adams during his mission to France during the Revolution, and a clumsy four-seated ottoman, brought home in 1868 by Charles Francis after his Civil War ministry at the Court of St. James's. Here are the household effects of four

remarkable generations of a family whose lives encompassed innumerable aspects, public and private, of the first century and a half of the Republic.

Here at Quincy, Charles Francis Adams pored over his grandfather's papers and edited the ten-volume *Life and Works of John Adams*, published at Boston in 1856. After his return from England he enlarged the service quarters of the house, and built in the garden a Stone Library, intended to provide orderly shelving for the books of three generations. In it he settled down to edit the *Memoirs of John Quincy Adams, Comprising Portions of His Diary from 1795 to 1848*, published in twelve volumes between 1874 and 1878. During summers in the Old House in 1887, 1888, and 1889, Henry Adams was writing his nine-volume *History of the United States from 1801 to 1817*. The family manuscripts, long accumulated here, have been given to the Massachusetts Historical Society, which, under the direction of L. H. Butterfield, has since 1954 been editing a multi-volume edition of *The Adams Papers*. Meanwhile the Old House in Quincy continues to offer a vivid reminder of the lives and interests of those markedly individualistic second and sixth Presidents of the United States as well as a number of their descendants.

A View of the Quincy Homestead,

Quincy, Massachusetts, 1930

A year after depicting the Old House of the Adamses, Rudolph Ruzicka returned to pause—as the text urges the wayfarer to do—before this ancient homestead of their kinsfolk. The first of the tribe in New England was Edmund Quincy, who came to Boston in 1633 and acquired extensive lands at Mount Wollaston in Braintree (now Quincy), but died about 1636. His great-great-grandaughter, Abigail Smith, married John Adams; their eldest son was named for his maternal great-grandfather, John Quincy (1689–1767), who had just died.

This house was begun in the 1680's by the second Edmund Quincy (1628–1698), who came to Massachusetts with his father, and became a justice of the peace, representative of Braintree in the General Court, colonel of Suffolk militia, and a member of the Council of Safety during the Andros troubles. The third Edmund Quincy (1681–1738) was, like his father, a colonel of militia and a representative in the General Court. He, however, attended Harvard College with the class of 1699; when he presented himself for his M.A. in 1702, his commencement part (in Latin, of course) undertook to refute the thesis that the existence of angels could be demonstrated by the light of nature! He evidently found Harvard congenial, for in 1701 he married Dorothy, a sister of the Reverend Henry Flynt (A.B.

1693), who was tutor at the college from 1699 to 1754 and

SISTE, VIATOR —

a Fellow from 1700 to 1760. Quincy became an associate justice of the Superior Court in 1718, and in 1737 was asked to go to London to assist in presenting to the royal government the Massachusetts case in the New Hampshire boundary dispute. While in London he was so forward-looking as to be inoculated against smallpox, and died of it a month later. Judge Quincy left an estate of £14,000. His daughter Dorothy married in 1738 Edward Jackson; a portrait of her as a girl inspired her great-grandson, Dr. Oliver Wendell Holmes, to write his poem 'Dorothy Q.,' although he admitted

> Who the painter was none may tell,—
> One whose best was not over well.

For a time after Judge Quincy's death in England, the house remained vacant, but in a few years his eldest son, the fourth Edmund (1703–1788), returned from Boston to live there. A member of the Harvard class of 1722, he had gone into business with his younger brother, Josiah (A.B. 1726), who went to sea while Edmund tended store and sold the goods. Subsequently their brother-in-law, Edward Jackson (also A.B. 1726), joined the firm. Their greatest stroke of luck occurred in 1748 when their privateer *Beth-ell* captured, in spite of its name, a great Spanish treasure ship, *Jesus Maria Joseph*, brought it into Boston, and made the partners rich. Nevertheless, Edmund before long was in financial trouble. He mortgaged his grandfather's house to Edward Jackson in 1755, and in 1757 was declared bankrupt. Jackson died in 1757: when his heirs foreclosed the mortgage, Edmund Quincy moved back to Boston. For the next century and a half the house was occupied by other families. In 1906 it was purchased by the Massachusetts Park Commission and the Massachusetts Society of Colonial Dames, the operation of it as a historic monument being

entrusted to the ladies of the Society, who provided most of the furnishings.

The house is of several periods and of irregular plan. At the back is the earliest part, a structure of four rooms on two floors, that may date from the dwelling of the second Edmund Quincy. The façade of the house and front central portion, also consisting of four rooms and two floors, are attributed to Judge Edmund Quincy's enlargement in 1706. In an ell projecting from the side of the house, the Judge built pleasant self-contained quarters for his bachelor brother-in-law, Tutor Flynt, to occupy when Harvard College was not in session. Flynt's study, which opens off the parlor at a slightly lower level, is a snug little room with panelled walls, bookshelves, and a fireplace, as well as its own outside door leading into the garden. A staircase in one corner leads to his chamber directly above, with an alcove for his bed. This perennial Harvard bachelor unhappily outlived his sister's and brother-in-law's vacation hospitality, for he became the oldest living Harvard graduate, a distinction that he held when he died on 13 February 1760 in his eighty-fifth year. By then the homestead no longer belonged to the Quincys.

A View of Minot's Light off Cohasset, Massachusetts, 1942

At Cohasset, southwest of Boston, a group of tide-swept rocks, known as Minot's Ledge, project into the sea. In foul weather they were lethal to fishermen as well as more important vessels returning to Boston from distant voyages. John Heyward's 1847 *Gazetteer of Massachusetts*, which listed lighthouses along the coast, indicated no such aid to navigation between the lights at the entrance to Boston Harbor and Cedar Point at Scituate. As more vessels than one liked to count piled up there, a lighthouse was built on Minot's Ledge in 1850, only to be demolished in a horrendous gale in the following October. The light shown in this last of The Merrymount Press keepsakes was achieved in 1860 on a site that Samuel Eliot Morison has characterized as 'more difficult even than the famous Eddystone.' Thereafter its beams, flashing one-four-three, warned shipping approaching Boston; as in Job 38:11, 'here shall thy proud waves be stayed.'

In the spring of 1858, while passing a Sunday in a hotel in North Scituate, Charles Francis Adams, Jr., went 'out to sail in a cat-boat, piloted by one of the Harveys, and visited first Minot's Ledge light, then in the course of erection, subsequently going up to the Cohasset Harbor stone yard in which the cutting and mortising were done, and the light-house in construction experimentally set up.' The hotel where Adams stayed was on a bleak rocky point pro-

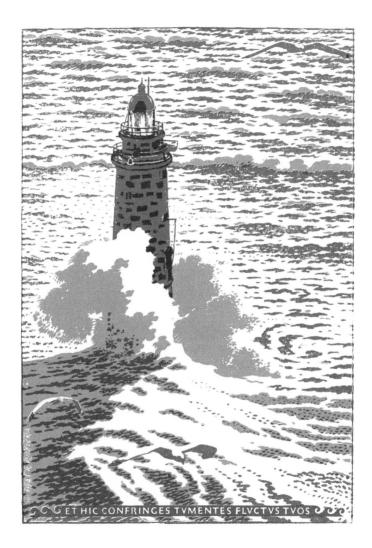
ET HIC CONFRINGES TVMENTES FLVCTVS TVOS

jecting into the ocean a mile south of the lighthouse; a more inappropriate name for it than The Glades could hardly be imagined. Although it had a superb ocean view, the wooden hotel did not long thrive, for the remoteness and roughness of this site were not congenial to the typical summer visitor. After the Civil War it passed to new owners that Adams described as 'toughs and gamblers,' but in 1874 it was turned into a club, where certain eminently respectable families summered. Bostonians have long had a taste for islands, or well-enclosed enclaves on the mainland, where they can live in high-minded discomfort in the company of relatives and close friends, usually at a cost that would seem to others disproportionately high for the simplicity of the accommodations. This bare, remote point admirably suited the eight Boston families who created The Glades Club. With land enough for privacy and solitude if wanted, here sailing, swimming, picnicking, walking, and tennis could readily be enjoyed. In 1880 Charles Francis Adams, Jr., and his brother, John Quincy Adams, each bought shares in it, without being aware that the other had done so.

The architecture of The Glades defied description, for the ramshackle square wooden hotel was embellished with wings, piazzas, cupolas, and other wedding-cake excrescences, while equally improbable cottages were built nearby. For some decades there was a communal kitchen and dining room, used by all residents. Abigail Adams Homans (John Quincy Adams's daughter) in her lively book, *Education by Uncles*, recalled: 'My uncles Henry and Brooks do not come into the Glades picture at all, although Uncle Brooks was once induced to come down there for lunch, only to remark later, "Oh, that is the place where they all eat in the cellar." That rather hurt our feelings, perhaps because there was a decided ring of truth in it—for our communal dining room was below the level of the land on

one side, though open to the sea on the other.' Bathrooms were late in coming, for the men dived into the surf from the 'bathing rocks,' while their families bathed 'off an ancient water-logged wharf moored in front of the house.' Although Henry and Brooks Adams preferred the Old House in Quincy, their brothers Charles and John, and many of their descendants, have made The Glades an Adams enclave that is now almost a century old.

Eventually the communal dining room was abandoned. Occupants of the cottages built their own kitchens and bathrooms, but the external appearance and the habits of the place have changed little. The sight of Mrs. Charles Francis Adams, wife of Hoover's Secretary of the Navy, painting a rocking chair on the former hotel porch, typified some of the contradictions of The Glades, for she was wearing an immaculate white dress, white shoes, and a Panama hat, while her uniformed chauffeur was holding the can of green paint at a convenient height. Another Glades incident that I cherish occurred during a clambake on the rocks, provided by Elliott Perkins, a grandson of Charles Francis Adams, Jr., and Master of Lowell House, 1940–1963, for his Senior Common Room. I was happily eating lobster in sight of Minot's Light, when I heard the Master's voice saying with authority to a Middle Western tutor: 'No, you damn fool, that's the part you *eat.*' And it was at The Glades in 1958 that Lyman Butterfield, editor-in-chief of *The Adams Papers*, who summers there with the descendants of his subjects, gave the surprise party that is mentioned at the end of my Preface.

This first edition of Boston
was printed by The *Meriden Gravure Company.*

*The type, Monotype Bell, is a traditional face, closely related
to the French designs of Didot and Fournier. It was first cut in
1788 by Richard Austin, a professional engraver, and issued
by John Bell of London, a publisher, bookseller, typefounder,
and printer whose avowed ambition was 'to retrieve and exalt
the neglected art of printing in England.' In 1864, Henry O.
Houghton brought to Boston a set of Bell's type cast from the
original matrices. The type resided for many years at the River-
side Press and was frequently used by Bruce Rogers under the
name 'Brimmer' and by D. B. Updike (who liked to pun on
'Merrymount' whenever possible) under the name 'Mountjoye.'
The type used in this edition, recut for the Monotype Corpora-
tion of London in 1930 under the supervision of Stanley
Morison, was set by* The Stinehour Press.

The paper is a special making of Warren's Olde Style Laid.